Winning Pictures

101
Ideas for Outstanding Photographs

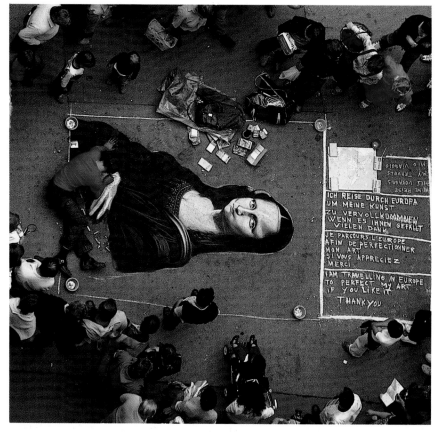

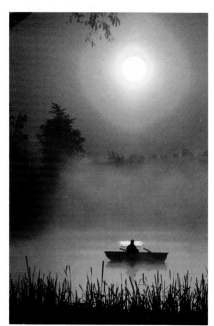

Published by
Silver Pixel Press
21 Jet View Drive
Rochester, NY 14624

Jeff Wignall is a freelance writer, editor, and photographer. He has written several books for Kodak including *Landscape Photography* and *The KODAK Pocket Guide to Sports Photography*. He has also contributed to several other Kodak publications, including *Photography with Large-Format Cameras, The KODAK Guide to 35 mm Photography,* and *Darkroom Expression*. Mr. Wignall is a former contributing columnist to the "CAMERA" column of the *New York Times* and writes frequently about both photography and travel for a number of national publications.

Publication AC-200
Winning Pictures
Printed in the U.S.A.
CAT No. E800 1299
ISBN 0-87985-016-7
Library of Congress Catalog Card Number: 94-62124

Cover Photo: Bessie Rosenfeld
KINSA/KODAK Photo Contest

Many of the photographs in this book are winners from the KODAK International Newspaper Snapshot Award (KINSA) contest.

101

Winning Pictures

Ideas for Outstanding Photographs

Written by Jeff Wignall

Contents

Winning Pictures

101 Ideas for Outstanding Photographs

This is a book of and about *winning* pictures. Most of the photographs in the book are winners in a very literal sense: they have won awards in either local or international contests. The majority of pictures were taken by amateurs and students; people just like yourself who have a love of photography.

The remainder of the pictures are winners of another type: we have chosen them because we feel they represent some of the most exciting pictures submitted from the ranks of working professional photographers, both Kodak staffers and freelancers. These are people who love photography so intensely they have made it their life's work.

More accurately though, this is a book about ideas. Because behind every winning photograph is a photographer who had a winning idea. All of us, at one time or another, have looked at a particularly exciting photograph in a book or magazine or on a gallery wall and wondered: Where does the photographer get such clever ideas? In the pages of this book, we'll look not only at the results of some very inspired ideas, but we'll probe the sources of those ideas as well. We'll also tell you how the photographer pulled off the idea—and we'll tell you why the photograph works. And we

will provide you with the technical information necessary to turn your own ideas into winning pictures.

But back to the main question. Where do great picture ideas come from? What is the fountain of invention and inspiration from which all these creative souls fill their cups? As you'll discover in the pages that follow, the places that ideas spring from are as varied as the subjects themselves.

Sometimes an idea or photo finds the photographer. While taking pictures after a storm, a rainbow suddenly soars across the storm-blackened sky—an idea is born. Other times photographs are completely set up and orchestrated by the photographer to fulfill a creative idea or ambition. In one photograph in this book, the photographer (with the cooperation of her subject) set out intentionally to take a picture for the KODAK International Newspaper Snapshot Award (KINSA) contest. And—it won. The picture is on page 19.

But in almost every case, the one common denominator that the photographers have named as their leading inspiration is a demonstrated love and dedication to their chosen subjects. Good nature photographers are invariably devoted nature watchers. Good people photographers are either gregarious people-loving people or astute social observers. People who

take funny pictures are usually people who enjoy looking at the lighter side of life. Being emotionally involved with your subject invariably leads to ideas that will help you capture the essence of that subject.

Finally, there are photographers who ignore the call of specific subjects altogether, and look instead to ideas inspired by the photographic process itself—often using aberrant or special techniques to create images that have existed previously only in their mind's eye. By intentionally casting convention aside or by trying a totally experimental technique, they blaze new paths into their own imaginations.

Whether your goal is to win a photo contest or just increase your enjoyment of photography, WINNING PICTURES will provide you with a wonderful mix of ideas, inspiration, and information.

Where do photographers get their winning ideas? Turn the page and you'll find 101 splendid answers.

DESIGNS

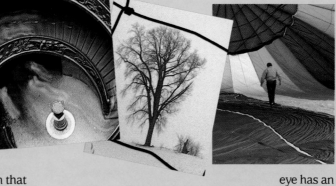

In most photographs, the basic visual elements—line, shape, color, form, texture—only fit together to build the larger visual components: a bridge, a barn, a parade. Sometimes, though, one of the elements becomes such an overwhelming and predominant part of a composition that it overshadows the content of the image. The elements, in effect, create a design that transcends content and becomes the subject of the photograph.

Photographs based mainly on the visual elements are great fun to create because there are no rights or wrongs, no good or bad. Anything that strikes your imagination's fancy may work. What's more, you can find potential designs almost everywhere—in the peeling layers of an old billboard, in the barren limbs of winter trees, or in the glass and steel grids of modern architecture. Once you begin to look past the obvious subject and explore it for its design potential, new worlds of photographic possibility reveal themselves—worlds you may have been staring at for years and never noticed.

Seeing the design potential of an object or scene is easier once you break it down consciously into its various design elements. Because these elements rarely exist in any scene entirely by themselves, you must strive to observe the most predominant existing element—usually the one that caught your attention in the first place—and find a way to turn it into a strong visual design. In the photograph of the windows (page 7), for example, by eliminating distracting backgrounds and framing the scene tightly, the photographer concentrates our attention on shapes in the scene.

At other times, you'll find it necessary to coordinate two or more different elements into one cohesive design. In the photo of the hot air balloon (page 14), for example, the photographer used both blazing color contrasts and strong inward lines of perspective to create an arresting design. In the very abstract design on page 15, the photographer has combined conflicts of color and shape to create a startlingly graphic and innovative image.

Perhaps the most powerful form of visual design is pattern. Whenever any of the major design elements repeat themselves, they form a pattern. Patterns are powerful because the eye has an almost irresistible desire to delve into them, to probe their repetition with the fervent curiosity and determination of a cat exploring a mouse hole. In the photograph of an industrial stairway (page 11), the photographer has organized the complex repetition of lines into an immediately recognizable pattern that implores the eye to linger and investigate.

Lastly, in searching for design subjects, remember that nothing is so invisible as the familiar. In the rush of our daily lives, we become so jaded to ordinary objects and familiar settings that we barely even see them; what's worse, we fail entirely to consider them as photographic subjects. The battered garden rake, the tomatoes ripening in the window, wet towels hung by the pool all can be eye-catching subjects—but because they are functional, we tend to ignore them. It is in these very commonplace objects that some of the greatest photo-design possibilities await you.

Eye-Catching Shapes

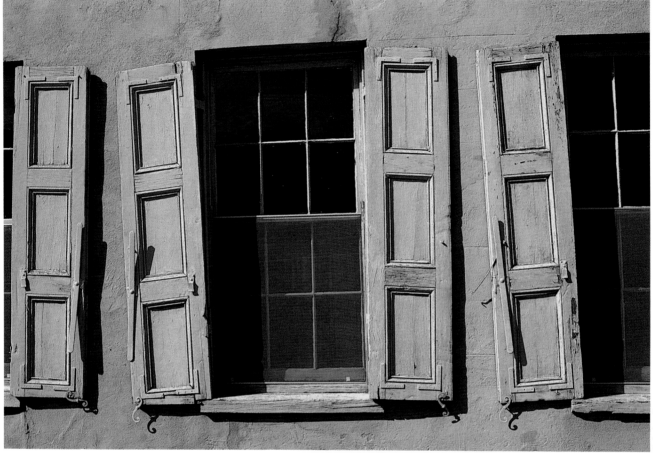

Kristina Rogers

Many designs rely on a particular shape, or combination of shapes, for their interest. As with pattern, the eye enjoys a great fascination with shapes of all types and description and eagerly seeks to identify all shapes encountered. Shapes can be regular—like the squares and rectangles here—or irregular like the branches of a tree. Designing with shapes is kind of like being a kid again and playing with wooden blocks; you can invent any arrangement or combination you want; if you don't like the result, you just knock it down and look for another opportunity.

In any design based on shapes, tight framing is essential. The best way to emphasize a shape or series of shapes is to move in close—either physically or optically. If the eye is distracted by the background, the design may be weakened. One way to accent shape is to create contrast—either in tonality or in color—between the main design and the background. In this scene, for example, both shutters and wall are painted in quiet pastels, but the difference in their colors emphasizes the shape of the shutters and windows.

While the two-dimensional shape of an object is a primary visual key to its identification, don't let it discourage you from exploring designs based solely on unrecognizable or unusual shapes. Although the shutters in this photo are of normal shape, their cock-eyed stance adds an appealing whimsy. When used as an element of design, shape can overwhelm the factual and logical associations. Irregular or abstract shapes, alone or in patterns, excite the eye and entreat it to explore.

Dramatic Viewpoints

Perhaps more than with any other subject matter, unusual viewpoints are a key to finding interesting visual designs. Unusual angles of view upset our normal visual orientation so that we can see and appreciate a subject for its inherent lines, shapes, or colors, rather than its purely utilitarian identity. Try turning a photograph of a familiar subject upside down and you'll see design elements previously hidden quickly pop into view.

Both of the photographs here are the result of taking advantage of extremely high viewpoints. High angles are particularly intriguing because in addition to revealing otherwise hidden design qualities in commonplace settings and subjects, they heighten the two-dimensional aspect of a scene. On a purely practical level, overhead perspectives also help you to eliminate distracting backgrounds and concentrate the attention on a specific area of design. They also add a dizzying, daredevil quality that may leave some viewers exhilarated and others a bit queasy.

Accessible aerial platforms are easy to find: rooftops, bridges, fire escapes, and upper-floor windows are all possibilities. The photograph of the conflicting patterns of awning and plaza above, for example, was made from a hotel balcony. Of course, the ultimate in overhead perspective is an aerial photograph. The dizzying picture of the suburban neighborhood was shot from a hot air balloon. Remember, though, the success of a high viewpoint does not depend so much on dramatic height as on freshness of the view. A design of lily pads may be fascinating when photographed from a sharply oblique angle just a few feet above the pond's surface.

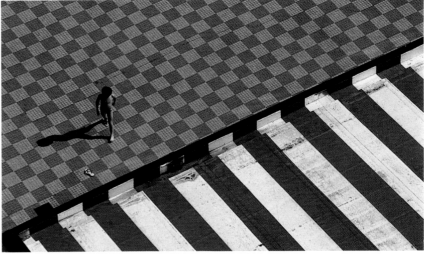

Stan Eames

Photographer's comments: *"I thought the optical design of the checker-patterned courtyard contrasting with the striped awning was just great. The boy running provided a focal point. I thought it important to make the awning appear to be an extension of the courtyard, so I stopped down the camera aperture to get as much depth of field as I could. I like the shot because it makes the viewer scratch his head and wonder what the setting is and where the boy is."*

Joseph N. Cherico

Photographer's comments: *"A balloon flight is spectacular and the views are so different! I enjoy both flying and photography. I made this shot while on a balloon ride in Phoenix. As we approached the other balloon I decided to take the picture straight down. I had to lean so far over the edge of the basket that the others had to hold on to my belt so I wouldn't fall out!"*

Fleeting Subjects

Autumn leaves scattered on a sidewalk, ripples on a pond, swollen raindrops dangling from maple buds—not all subjects come in fixed or tangible forms. Some, like this momentary shape upon the sand, are as changing as the tide.

Subjects as fleeting as a footprint in the sand elicit strong emotional responses from viewers. The short-lived nature of such subjects can remind us that life itself is slipping by, that a loving toddler quickly becomes a rambunctious teenager, that a glorious vacation in the Alps soon gives way to the eight-to-five routine; that is the power wielded by the short-lived subject.

Much of the fun of capturing such designs on film is knowing that they are short-lived and that if you don't catch them when you see them, away they'll vanish. Watch sometime, as the ebbing sea carves a sandbar, or a harsh wind shapes and reshapes snow drifts. See how different one moment's designs are from the next.

Some transitory designs—like the wake of a boat—can be caught only by fast work and fast shutter speeds. Any hesitation and the pattern will forever disappear. Other designs, while still temporary, change more gradually—clouds, the migrating sands of a dune, or a row of sailboats tugging at anchor. Use these slowly-shifting patterns to capture a series of evolving images. Other transient designs are longer lived. Lacy frost designs on a winter window pane, for example, may linger for days before surrendering to a warm, sunny day.

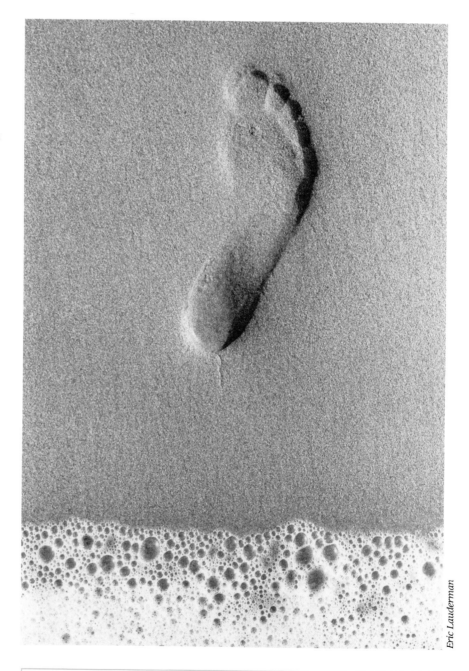

Eric Lauderman

Photographer's comments: *"This photo was taken during a camping trip with my family. I stepped into the wet sand and waited until the tide edged into the frame to take the picture."*

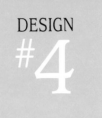

Architectural Details

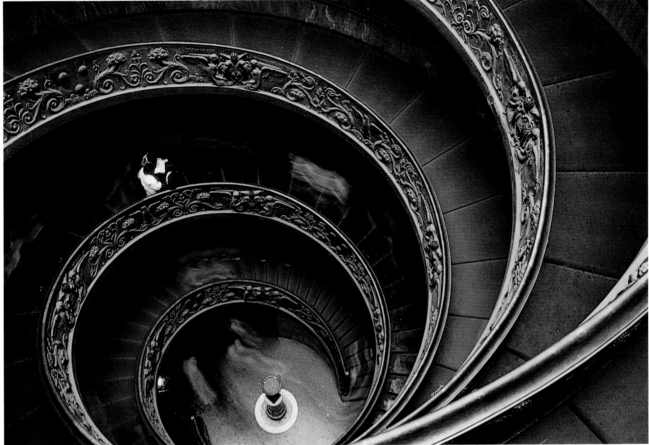

Robert J. Lennon, Jr.

When you consider that architecture itself is the merging of the art and the science of design, it's not any wonder that architectural subjects provide a wealth of possibilities for photographers. From the simple symmetry of a row of condominiums to the random rectangles of a city skyline to the ornate filigree of a Gothic bell tower, architecture abounds with enticing design elements—both in structure and detail.

The key to uncovering the best design compositions in architectural subjects lies in exploring them from various viewpoints; and very often, changes in viewpoint will provide very different interpretations of a particular element's design qualities. Photographed from above, this stairway in the Vatican museum exhibits a wonderful spiraling rhythm that carries the eye on a concentric journey from the edges to the center of the frame and back out again. Photographed more obliquely from part way up or from directly underneath, the elegance of the stairway's design would remain, but its design impact might be entirely different.

Because color is often subordinate to design in architecture, black-and-white film can produce a stronger photograph. In such cases, you can choose KODAK T-MAX 400 Professional Film indoors for its high speed, extremely-fine grain, and excellent sharpness. Outdoors, use KODAK T-MAX 100 Professional Film.

As with any design composition, you must frame architectural elements with utmost care to exclude any extraneous material that might distract from the theme.

Line Patterns

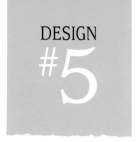

Individually, lines can serve a lot of functions in creating a photographic design. They can lead, unify, connect, separate, define shapes, and perform at least a dozen other valuable services. Repeated in a pattern, they can instill a design with a sense of order, rhythm, or unity. The shape and direction of lines that make up a pattern can also be used to suggest a certain mood: the swirling fronds of a fern convey a soothing, relaxed feeling; the staunch vertical lines of a pine forest seem formal and rigid.

Many line patterns are so obvious that they almost shout at you when you aren't even looking for them: picket fences, sailboat masts, a painted parking grid. But even for such conspicuous patterns to work as an effective design, you must make them obvious in your photograph. With three-dimensional subjects (a row of parking meters, for instance), this may mean finding an angle that sets your pattern boldly against a plain background. In this shot of an industrial stairway, the photographer used a low angle to isolate the brilliant white lines against a plain and contrasting blue sky.

Also, while line patterns sometimes occur in natural isolation, they are just as often part of a more complex situation. In the rungs and railings here, for example, lines of several different shapes and orientations (curved, straight, diagonal, horizontal, vertical) are creating a number of integrated patterns. Take your time in finding a viewpoint and composition that organizes these conflicting elements into a coherent design.

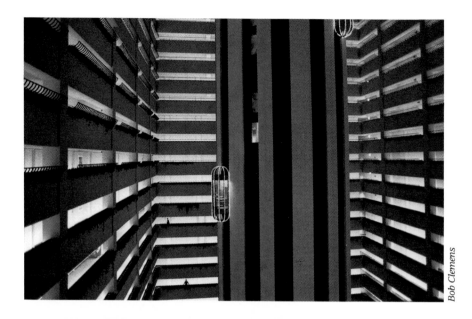

Bob Clemens

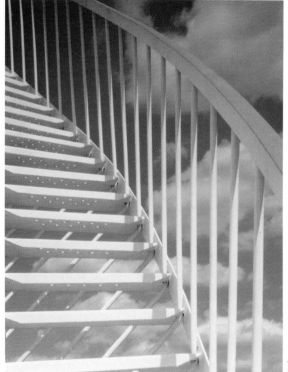

Brian Lemay

Bits and Pieces

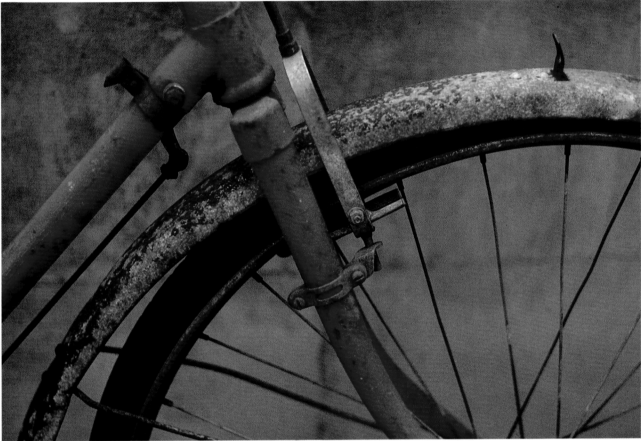

Dan Neuberger

Too often we are so intent on viewing only the *whole* object or the *entire* scene that we ignore the many smaller elements that make up the larger view. We see the tree, but not the sinuous curves of the protruding roots. We notice the old shed, but not the rusting door latch. Learn to investigate isolated pieces of objects for the many interesting designs hidden within them.

Machines and mechanical devices are particularly plentiful sources of such concealed beauty, since they often contain complex graphic combinations of lines and shapes. The contrasting curves and angles of this rusting bicycle, for example, create a graceful, flowing rhythm that is generally ignored when the bicycle is seen as a whole. Interestingly too,

your choice of subject matter can have a powerful effect on the mood of a given design. The decaying condition of this bike can evoke nostalgia for one's childhood, just as the more sleek shapes and slick details of a modern bicycle could convey a sense of the contemporary.

Fragments of simple objects can lend themselves to interesting photos too. A closeup of just the edges of some nested pottery can create a beautiful design; the portions of different curves and heights can create their own flow like a pattern of mountains. A shiny handle on a brightly-colored car door, a few repeating posts from a whitewashed, New England fence, or even a single flower petal have much to offer in the simplicity of its design.

A good way to spot the inherent design possibilities of object fragments is to isolate and frame them with a moderately long telephoto or telephoto zoom lens. By using the confines of the viewfinder to limit your peripheral vision, previously unseen design possibilities become readily apparent. Once you uncover a photogenic design, study the arrangement of the key elements within the frame. By limiting the elements, you'll find it easier to organize them.

When your camera is not in hand, practice viewing the world in bits and pieces. Try to notice single colors, abstract shapes, and fragments that appear as parts of a larger scene. You may discover the beauty in things you never noticed before.

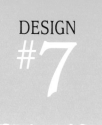

Tonal Contrasts

J. Mitchener Covington

Like contrasts in color, contrasts in brightness or tonality can be a powerful weapon in your design arsenal. Tonal contrasts occur whenever you shoot a dark subject in front of a very bright background, or a brightly lighted subject in front of a dark background. You can use tonal contrasts purely for design sake—to feature a shape or pattern, for instance; or as compositional devices—to accent a particular element within the frame. In composing this scene, for example, the photographer has exploited the extreme contrast range between fore-

ground and background to frame and punctuate his center of interest. By including a large chunk of foreground in silhouette, he has used contrast to reveal the rugged contour of the topography, as well.

Exposing tonal contrasts properly is crucial in gaining their full effect. Rather than taking an overall reading and balancing your exposure between highlight and shadow, take readings from, and expose for, the highlight regions only, when using color-slide films. Using an averaged exposure (or exposing for the shadows) would

diminish the intensity and suspense of the contrast. When making pictures on color negatives for prints, expose for the average reading or lean towards the shadow areas. Also, because dark and light areas will be vying for the eye's attention, it's especially important that you take care to create a feeling of balance between the dark and light areas; so that one doesn't overpower or outweigh the other. Since darker areas are considered "weightier" than light ones, it's usually best to offset large dark areas with even larger bright areas.

Color Contrasts

Dell Jackson

Almost like electrical currents zapping our optic nerves, color contrasts make powerful eye-catching designs—particularly when they're as vibrant and extravagant as those shown here. No matter what the source, it's hard for the eye to turn away from something as attractive as a grouping of bright colors. But while brilliant colors alone may snatch attention, their attraction is rarely enough to hold interest for long. To design with color, look instead for situations and subjects where bold lines or shapes are an integral part of the color theme. Here, for example, the photographer used a wide-angle lens to exaggerate the strong converging perspective of the color stripes to pull the eye ever deeper into the frame. Subconsciously we know that the photographer was inside the balloon when he took this picture, so we have a gentle sensation of being fully enveloped by bright colors flapping as the balloon is inflated.

Two kinds of lighting work well with color contrasts. With solid or opaque subjects, harsh, full, frontal daylight works best. The clean lustrous light of a cloudless, midday sun is particularly useful since its neutrality leaves colors pure. A polarizing filter, that cuts surface glare and reflection, will saturate colors even more. For translucent subjects like this hot air balloon, strong backlighting ignites colors with an incandescent brilliance. If you use color slide film, underexpose it slightly (1/2 stop) to enhance the richness of the colors. Choose a film capable of carrying the bold colors such as KODACHROME 64 Film.

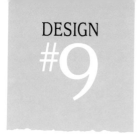

Abstracts

Dan Neuberger

Because photography is often considered a true-to-life medium, many photographers have a hard time breaking away from the accepted conventions of what a photograph is supposed to look like. We're hung-up on reality. We make boats look like boats, buildings look like buildings and avoid any subject that isn't recognized instantly for what it is. In most cases, showing people what they expect to see is the safest road to a positive response. But when it comes to photographing interesting designs, creativity often blossoms best by tossing caution—and reality—out of mind.

Hiding all about us in the most unlikely of subjects are a wealth of intriguing abstract designs. You'll find them in the rusting pipes of an industrial complex, the garden hose coiled on its hook—or the snow dappled roof of a brilliant, red barn. Abstract designs can lull us with a sweet, soft sensuality or wow us with a disturbingly unsettled brashness. They can demand our attention or seduce it. In this photo, saturated colors and graphic shapes combine to make a bold image. The red and blue colors are enriched by the brilliant snow and deep black roof. Aided by the top border, the peak of the barn and the roof form a strong angular shape in the sky. But, the many angles are relieved by the serrated curve of the snow on the roof—all, and all, a powerful abstract of shapes and colors.

In the hunt for abstract designs, see your subjects not for their functions or their familiar fronts, but for the cohesiveness or conflict of their shapes, the rhythm or riot of their lines, or the clash or harmony of their colors. Try looking at familiar objects from unfamiliar viewpoints: How different does the fire escape look from underneath than from across the street? Elements found, use the four borders of your viewfinder to isolate or combine them into challenging graphic arrangements.

Photographer's comments: *Unfortunately, most people turn their eyes, and cameras, only to generally accepted beautiful scenes. There is beauty in color, design and texture all around us. I try to isolate the essential, simple elements of a scene from the cluttered whole presented to my eye. Sometimes I succeed.*

Natural Frames

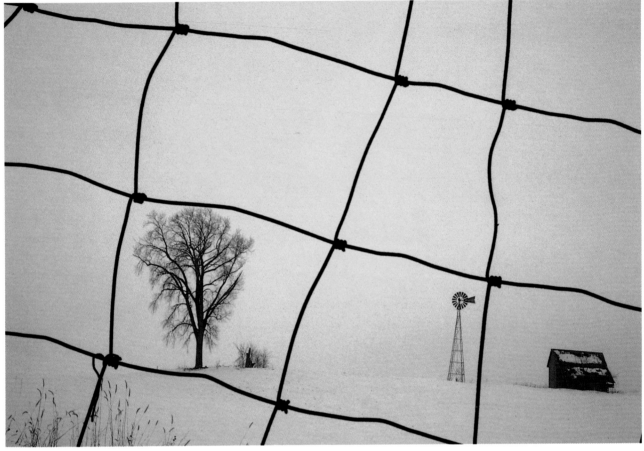

© *Richard Hamilton Smith, 1982*

Most of the photographs in this chapter have been concerned with using visual designs as subjects unto themselves—design for design's sake. Frequently you'll find situations where you can incorporate a dynamic design as an element in a broader composition. One common way is to use an interesting foreground design as a framing device for a larger scene. By photographing this wintry landscape through a surrounding fence, for example, the photographer has added a compositional twist to an otherwise minimal scene. Also, by carefully pigeon-holing the various farm elements into separate fence openings,

he has allowed us to view the scene as a whole, and to make our own comparisons of its various individual components.

Interesting frames are rarely obvious at first glance; usually you'll have to dig a little to discover them. The best way to find them is to study and explore your subject from a variety of angles and at a variety of distances. Get yourself in the habit of looking at your subject through objects—windows, tree branches, doorways—so that you can begin to notice frames instinctively. But beware of the danger of using too powerful a framing device, which can

quickly dominate a scene and subjugate the main subject. You can usually reduce this effect if there is a strong thematic link between frame and subject—as the wire fencing reinforces the farm theme in this scene.

Photographer's comments: *"The fencing was used as a depth-of-field element. Made with a 24 mm lens. The old farmstead is a favorite place to visit."*

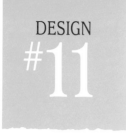

Picture Parts

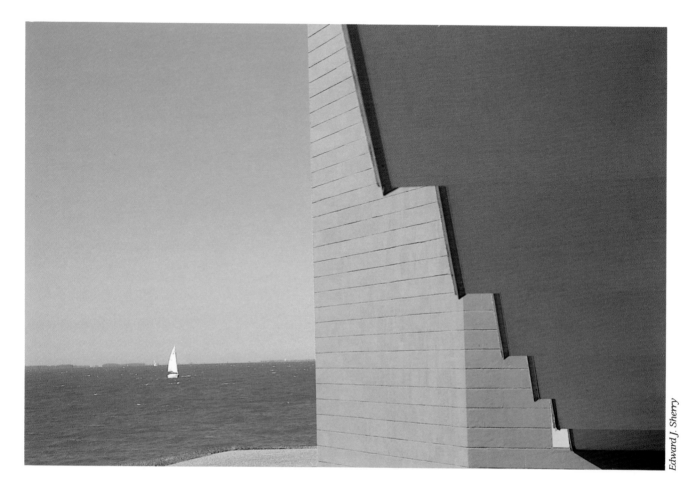

Edward J. Sherry

One interesting way to create powerful visual designs is to intentionally divide the picture. By carefully arranging the resulting segments like pieces in an abstract jig-saw puzzle, you can create feelings of balance, imbalance, tension, or even discord. In the dynamically geometric scene depicted here, the photographer has divided the frame into a complex series of shapes within shapes and frames within frames. The counterbalance of various areas of small against large, bright colors against dark, and jagged lines against straight, creates a series of visual conflicts that keep the eye bouncing from one part of the scene to the next. Yet in the end, the conflicts combine to make a unified picture.

Where you place the divisions within the frame has an immediate impact on how the viewer perceives the mood of the scene. Perhaps the most familiar example of this is deciding where to place the horizon line in a landscape: Place it low and the sky dominates, place it high and the foreground becomes expansive. Although the sky occupies only about a quarter of the frame in the scene here, the low horizon leads to an unmistakable feeling of distant spaciousness. Similarly,

the dominating size of the building lets us share the sense of immediacy that the photographer must have felt when viewing the scene in person.

While using such a fragmented approach to design might at first seem disorienting or confusing, such scenes frequently parallel the segmented glimpses of the world that confront us daily. Doors, signs, buildings, trees and other obstructions continually divide and re-divide our vision of the world.

Photographer's comments: *"The auditorium is a distinctive landmark with its unusual raspberry-pink colors contrasting with the blue-green water...I felt that there were graphic possibilities that could be combined with the unique colors. I shot from under the saw-toothed soffit to produce a strong, graphic line...The soffit shadowing gives the appearance of the building's side being cut away."*

H U M O R

Life is full of wonderfully silly and absurd moments, and the ability to recognize and enjoy them is a marvelous gift. Hardly a day goes by when most of us don't see something that prompts an unexpected giggle or a sudden laugh, and it's only natural to want to share these moments with others. But of all the emotional responses that a photograph can provoke—awe, empathy, joy, fear, passion, warmth—perhaps none is quite so difficult to convey as humor.

The dilemma of relating humor is greater than relating most other emotions because humor is an entirely subjective matter. What makes one person guffaw may puzzle another. And to be understood by anyone, the humor in a photograph must be blatant—verbal explanations after the fact won't help. A photographer pointing out why a particular photograph is funny is like a comedian explaining why you should be laughing at the joke.

Another problem in photographing humor is that funny moments are ephemeral, fading even as they occur. If you aren't prepared, camera poised and at the ready, odds are that the humor of the instant will slip past before you even reach for the lens cap. Since few of us have a camera in hand every waking minute of the day,

it's certain that you're going to miss far more funny moments than you'll capture. To overcome the odds you must be on the lookout constantly for humorous incidents—and learn to respond to them quickly.

Where do you find funny pictures? In searching for humorous photographic situations, don't look as much for specific subject matter as for humorous concepts. While there are some subjects that seem to lend themselves more readily to humor than others (children and pets, for example), you don't always have the luxury of having them nearby. On the other hand, you can apply humorous concepts to almost any situation or subject.

Incongruity, for example, is a plentiful source of visual humor. Sometimes you'll find incongruity in the form of an uncharacteristic action—such as the man delighting in an impromptu hose bath on page 22. Humor often

appears in the incongruous relationships between people and their surroundings—as shown in the photo of the jolly man posing with the laughing Buddha on page 20.

Another concept similar to incongruity is juxtaposition, where seemingly unrelated elements fall together in unusual or humorous ways. See the photo of the ladies' underwear with a sign for sunglasses; page 28.

Yet another powerful purveyor of humor is surprise. In the photo of the two bulls dueling for territory, page 24, the situation is funny mainly because it's not the kind of traffic problem we expect to see when driving down the highway. Of course, not all "surprises" come as a surprise to the photographer: The picture of a young couple about to share a rather wet and unexpected surprise of their own, page 19, was instigated and orchestrated in full by the photographer.

Wherever you find your humor, and whether you come upon it naturally or you plan it intentionally to fulfill a creative idea, don't expect all of your pictures to look as funny in the final product as they looked to you in the viewfinder. Like a poorly-delivered joke, sometimes the humor gets lost in the translation.

HUMOR
#12

Practical Jokes

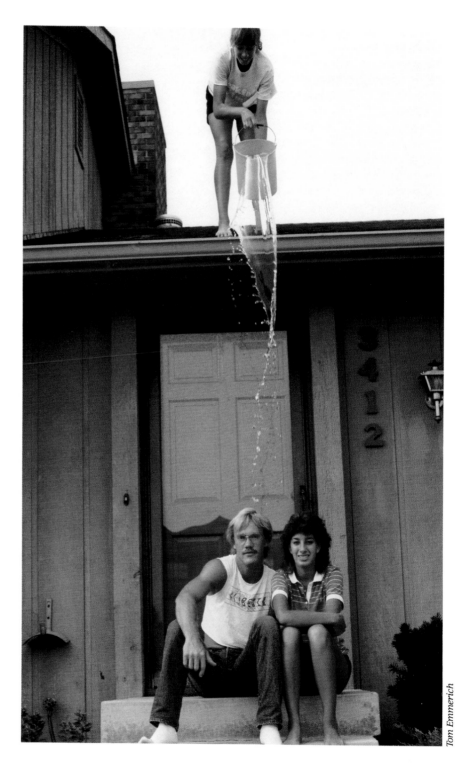

Not all funny picture situations are discovered by accident. Some, like this one, are cleverly arranged. Planning such an outrageous scenario takes a little luck, a slightly devious imagination, and a lot of nerve. Although this photograph was definitely a setup, strangely enough it didn't begin as an idea for a photograph. The photographer describes how the situation came about: *I was in the kitchen (the camera happened to be on the counter) when my youngest daughter, Casey, came in soaking wet. Her older sister, Michele, and her boyfriend had sprayed her with the garden hose. She was furious. I said to her, 'Don't get mad, get even.' Then I created a diversion so she could get even. I got Michele and her friend to pose for a picture. I told them I was near the end of a roll of film that I wanted to finish. Meanwhile, Casey had gotten onto the roof with a bucket of water. Just before Casey dumped the bucket, I told the posing couple that this would be a picture they would never forget!* Timing for this shot was everything. If the photographer had pressed the shutter an instant sooner, the intent of the event might not have been clear. Pressed a split-second later and the peak of anticipation would have passed. By photographing the event when he did, the photographer has allowed the viewer to share totally in the expectation of the surprise.

Self-Humor

One of the things that people enjoy seeing in pictures is other people who are able to laugh at themselves. While there's nothing inherently humorous about a man exposing his portly belly to the camera, the same man jovially comparing his uncanny physical resemblance to Buddha's puts the scene into a totally different and amusing perspective. Such lack of self-consciousness is a quality that we all can envy and enjoy.

Getting some people to drop their everyday masks in front of the camera is easy. There are a lot of natural "hams" who love to be in the limelight—if only for a quick snapshot. The photographer who made this photo was lucky because the subject (her father) chose the pose himself. With less gregarious people, you may have to work a little harder at drawing them out. One way is to set up a silly situation and promise them that you'll pose for their camera if they'll pose for yours. Such a challenge between friends or relatives usually sets up a fun competition that results in a round-robin tournament of clowning and one-upmanship.

Fun pictures like this one—especially if made during a trip—are almost always the hit of a travel-slide show or photo album shared with friends and relatives. Long after the standard shots of famous landmarks and scenic views are forgotten, the slide of Dad laughing with Buddha will bring fond smiles of remembrance.

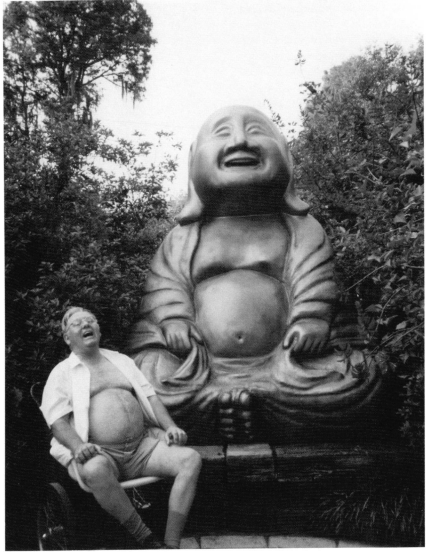

Roberta A. Popp

Absurd Poses

Little girls in party dresses don't normally wear paper plates on their faces and families gathered at a holiday dinner don't usually balance spoons on to their noses—but the unexpected poses bordering on the absurd makes each of these photographs so much fun to look at. Both photos are even funnier because the subjects themselves seem so nonchalant about the incongruity of their actions.

Family get-togethers and special occasions like parties are a great time to look for or create silly picture situations because your subjects are relaxed and they're there to have a good time. You can work candidly and try to grab pictures of people unaware or actively seek out a comical pose, as did the photographers of these photos. Your success at getting family or friends to strike such off-beat postures will depend largely on what kind of family and friends you have. But with any group, you'll almost always find them more willing to pose for a fun picture than for a stiff-formal one.

Don't just leave your subjects on their own to come up with ideas: Pose a silly suggestion as a challenge and see how they respond. With kids' parties, games or activities that are part of the fun often lead to good picture situations. Of course, if you happen to have a family that has a bizarre trick (like keeping spoons balanced on their noses) in their regular repertoire, so much the better.

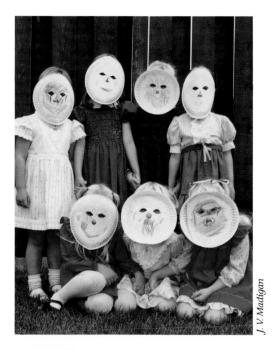

J. V. Madigan

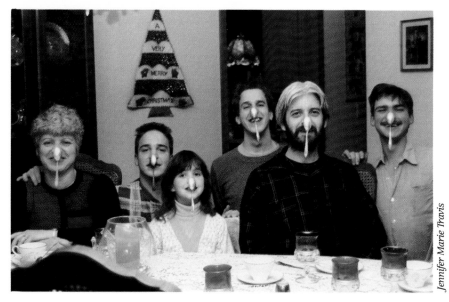

Jennifer Marie Travis

Gleeful Moments

Children and babies don't have any corner on the silliness market. Some of the most humorous people pictures are those in which adults are caught in the simple act of enjoying themselves. A dozen times each day—usually without even noticing it ourselves—each of us steps out of our carefully controlled adult role and behaves totally without pretense or inhibition. We wrestle with the dog, make faces in the mirror, and may even occasionally douse ourselves with the garden hose. What makes photographs like this one so amusing is that we can all relate to the honesty and spontaneity of the occasion—and the subject's utterly gleeful expression.

One of the keys to recording such candid and whimsical moments is getting your friends and family used to being photographed—not just on holidays or special occasions, but all of the time. Once they accept the camera as a part of their everyday lives, they're more likely to behave honestly in front of it—and in turn you'll feel less awkward about pointing it at them.

Of course, not all families will adapt quickly to the constant presence of a camera. Before yours does, you may have to endure a few shrieks, dodge some bric-a-brac, and resign yourself to banishment in the basement on the rare occasion that tempers flare. So, be sensitive and sensible. Capture everyday spontaneity for great photos—not hard feelings.

Photographing transitory expressions like this one requires good candid technique, fast reflexes, and a fast film. In black-and-white, a fast film like KODAK T-MAX 400 Professional

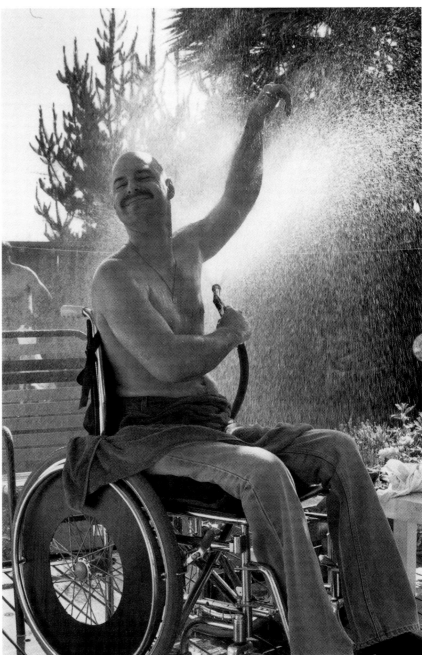

Diane Bush

Film provides the very fast shutter speeds you need to grab such scenes at their peaks. The exposure latitude inherent in this film can make it excellent at recording the full tonal range of brilliantly backlighted scenes.

Incongruities

Patricia A. Weber

What do a bottle of wine, a fish's head, a starfish, and a girl in sunglasses blowing against a glass-top table have in common? Nothing actually—and it's the incongruity of the subject matter that makes this picture so startling and amusing. Part of the fun comes from seeing such an odd complement of subjects, and part comes from wondering what sort of demented souls would cook up such a visual stew. Two friends worn out from a workout conspired to make this bizarre tableau. With the table-lamp next to her, the photographer squirmed under a glass-top table and took the photo as the friend pressed her face against the glass.

That such a picture *is* fun to look at just proves that you can't always describe in words what makes a photograph funny. If you tried to describe the humor of this shot to others without showing them the picture, they'd probably just stare at you awhile and then walk away. Nor could you easily plot out such an image and try to visualize its humorous potential. Pictures like this are whimsical events, created in the peak of spontaneity and as impossible to duplicate as they are to explain.

One thing pictures like this can do is give you a pretty good clue as to the fun-loving and uninhibited nature of the partners-in-eccentricity who created it. These are the kind of people that invent their own entertainment, as well as their own photographic rules. And if you share their somewhat bizarre sense of humor, just looking at this picture probably makes you wish you knew them.

Photographer's comments: *"This photo was shot from under a glass table top as my friend Merry was blowing into the glass. The fish-head is compliments of a local A & P where we stopped to get some dinner for ourselves after working out. Shooting this picture was great fun. We laughed hard enough to cry."*

Surprise

<div style="writing-mode: vertical">Scott S. Theison</div>

Many humorous photographs are the result of pure serendipity; the photographer just happens to be in the right place at the right time. But being there and seeing the humor in a situation are two different things. While many people could have seen nothing but inconvenience (or even fear) in two bulls locking horns across the highway, this driver was able to see the absurdity of the event. That two bulls appeared on a road in opposite lanes, in the middle of nowhere, and locked horns directly over the center stripes could be viewed as an allegory of drivers everywhere, as an absurd coincidence, or just plain hilarious. Fortunately, the driver had a camera on the front seat of his car, ready for picture-taking, as if he had expected such a sight to appear. This brings up another point—while no one can predict such humorous happenings, you can be ready for them.

The best way to stay prepared is to keep a loaded camera with you all the time—not just when you're traveling or scouting for pictures, but *all of the time*. (Many photographers keep an inexpensive camera under their car seat just for this purpose.) You must also learn to react like a journalist: Be quick and sure. Two bulls locking horns may linger for hours—or they may vanish in the click of a shutter. The photographer here exposed only two frames before his subjects vanished from whence they came.

Uninhibited Fun

Norma Tarelia-Matley

There's something about children and mud that always seems to inspire them to new heights of mischievous behavior. Whether it's youngsters damming a backyard brook after a rainstorm or a group of teens relishing an afternoon of impromptu mud-football—wherever a fresh supply of mud and kids meet, freewheeling (if not somewhat sloppy) escapades are sure to follow. To a parent such mucking about may give pause, but to a photographer it will provide some wonderfully humorous photo possibilities.

One of the great things about children and mud (from a photographic standpoint, at least) is that they're usually quite pleased with their appearance—the muddier they are, the more fun they're having. Getting mud-laden kids to pose for a close-up portrait is usually no problem. But if you want to get more candid shots, use a medium telephoto lens and work from a distance. Even if they notice you, they'll likely soon forget your presence and go back to their dam construction or mud diving.

This photo, once again, also illustrates the importance of being prepared—of having a camera with you at all times. The photographer was simply driving by when she saw the mud-covered boys. Without a camera at hand, this photo would not have been possible. Be prepared.

In any event, remember that while children and mud usually mix well, cameras and mud don't. If there's a lot of splashing going on, keep your camera inside a plastic bag and keep a skylight filter on the lens to protect it. If you get mud or water on the outside of your camera, wipe it off immediately with a clean handkerchief, being careful not to scratch delicate parts and the finish.

Photographer's comments: *"I was driving by a local field when I saw these boys just completely covered with mud—they looked like creatures from another world! When they saw me walk toward them with my camera, they began to come closer to me; I said 'stop' and shot the picture."*

Comical Gestures

Babies would probably be incensed if they knew the number of laughs that come at their expense, but their amusing antics and comical gestures are a never-ending source of humorous photographs. And no matter how many funny baby pictures we see, the enjoyment never seems to wear thin.

Since most babies-even very young ones-are natural mimics, it usually doesn't take much effort to lure them into a spell of silliness. Make a silly face and you'll likely get a sillier one back. All babies like being the center of attention and will react eagerly to your attempts at animating them. Meal and bath times are especially promising opportunities for funny pictures since such adventurous (for baby and parent) situations lend themselves well to lively behavior.

Because it's hard to be both entertainer and photographer simultaneously, it's usually best to have someone else—a parent or sibling—keep the baby amused while you snap pictures. Indoors, flash is a good idea because it will provide extra lighting and its short duration will freeze those prize-winning reactions. If you prefer to use existing light, use a very high-speed color print film. Remember too, babies come in small packages. So move in as close as your camera allows and let the image of the baby fill the frame.

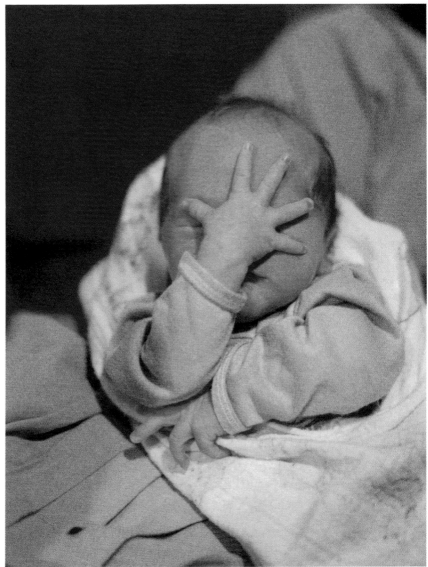

David Bates

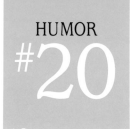
Funny Faces

Dean L. Olson

One sure (albeit easy) way to get a laugh with a photograph is to have someone (and in this case something) make a funny face for the camera. And why not? As babies, one of the very first ways we experience humor in life is laughing at our parents ceaseless attempts to get our attention by making silly faces. Later, when we're old enough to realize that making a face is a good way to get noticed or grab a quick laugh, it becomes a part of our childhood arsenal.

Young children are, of course, the ultimate face-making champions since they tend to find motivation in everything from the broccoli at dinner to Dad's stale jokes. And it usually doesn't take much provocation to get any child to demonstrate the latest in grotesque facial disfigurements. If kids run stale on ideas when the camera is brought out (and that's usually the only time they will), do what the photographer did here and give them something to mimic. Few children could let such a challenge go unanswered!

And finally, don't discount adults as a source of ridiculous facial expressions. When the adults are vying for attention from the baby by making faces, turn your attention and your camera around to the adult. Or during more serious moments, be an instigator yourself by making faces and asking for a challenge from friends. After all, inside every straight-faced adult there is probably a tongue-wagging 10-year-old trying to get back out.

Sign Juxtapositions

Signs of all kinds are a particularly common and plentiful source of visual humor. Most sign humor comes from odd juxtapositions between signs and their surroundings or conflicts between signs and other signs. The greater the apparent contradiction, the funnier the picture becomes. It's clear, for example, that those aren't sunglasses in the sale display and the blunder is humorous.

Sometimes the discrepancy between a particular sign and its surroundings is blatant (as it is here) and requires only a straightforward point-and-shoot technique. Other times, the humorous connection that you see may be more obscure and you'll have to resort to special techniques or optical tricks to make it more obvious to the viewer—for example, using a telephoto lens to compress the distance between a "Get Gas Here" sign at a gas station and a "Diner" sign down the block.

Often, too, you can use a slight shift in viewpoint to establish a false context—shifting camera position, for instance, to include a "No Exit" sign near the entrance to a cemetery. Or you can use a camera's inherent ability to crop out context to create a different type of humor. For example, two "One Way" street signs, pointing in conflicting directions may not seem at all confusing in the context of an intersection, but crop away their surroundings and they create an amusing and ambiguous pictorial message.

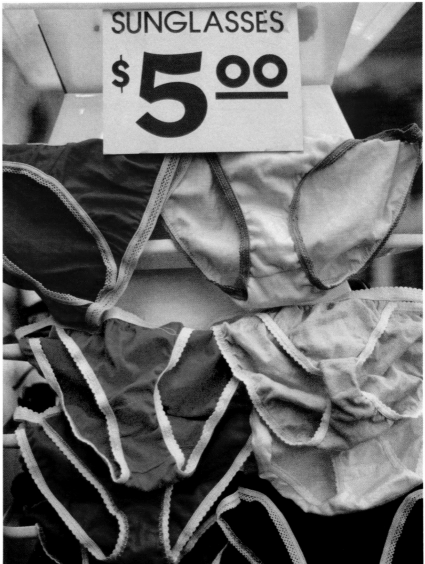

Adriana Lopez

28

Pet Antics

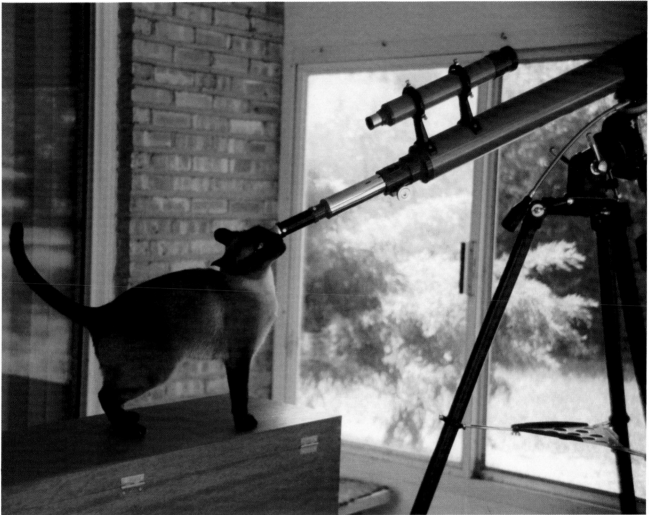

Jacqueline Harris

Cats, dogs, and other pets can be comical, and their everyday routines and actions can provide some very funny moments to capture on film. Because you are usually familiar with any peculiar habits or quirks your own pet has, you can often anticipate or create funny picture situations.

Pet tricks are a good source of funny pictures—and the more outlandish the trick the better. But if the trick requires any human assistance, it's best to have someone else work with the animal while you take the pictures. If you try to aim and focus a camera while attempting to get your

poodle to balance on a basketball, you're likely to be the one to come out looking the silliest. For action shots, don't expect to get the timing down perfectly the first time; you'll probably have to take several pictures. Part of the challenge can be in getting your pet to repeat its antics.

The humor in pet pictures depends often on props that make the pet seem to be mimicking human behavior. In addition to this star-gazing cat, we've seen dogs posed at the driver's wheel of a parked car, behind a typewriter, donning sunglasses or a hat, and even apparently reading the morning paper at the breakfast table.

Most funny pet pictures, though, are simply spontaneous bits of unexpected or cute animal behavior—like this Siamese cat apparently scanning for birds through a telescope—that may otherwise go unnoticed. With cats and kittens, often their natural curiosity and propensity for mischief leads to funny situations—a cat caught taking a swipe at the goldfish, for example. Even simple animal activities—yawning, washing, stretching, or pouncing on a favorite toy—can be hilarious if you're prepared and catch them at just the right moment.

29

Kids and Animals

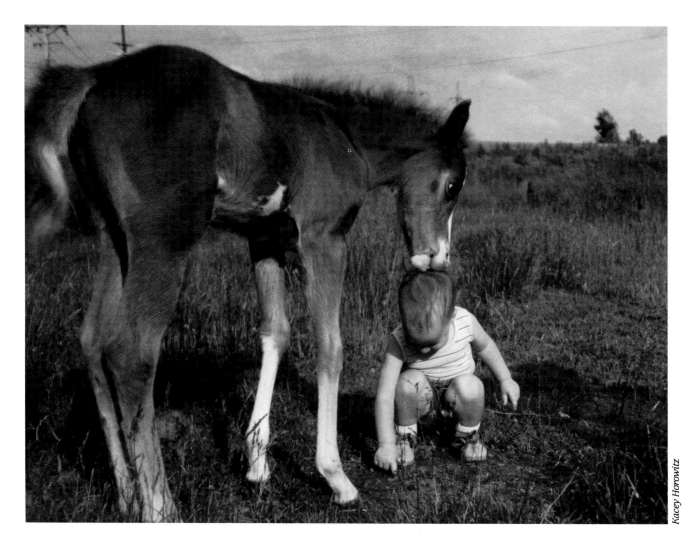

Kacey Horowitz

Any time children and animals get together, humorous happenings are likely to follow. But almost always, such humor is the result of some all-too-brief action or reaction (by animal or child), so you have to be watching and be prepared to react at all times. The pose of this pony, apparently grazing on the toddler's hair, probably lasted only a brief second, but because the photographer knew that horse and child shared a mutual affection, she anticipated the moment and had her camera ready when it occurred.

Since they tend to gravitate toward one another naturally, finding (or put-ting) kids and animals together is rarely difficult. The adventures and misadventures of pets and kids are always a good bet for potentially funny incidents, such as a group of neighborhood youngsters giving a shaggy dog a shampoo, or little girls "dressing up" the cat. Petting zoos, where children interact with domestic or farm animals, are also good places to expect humorous occurrences.

Toddlers getting their fingers nipped while feeding a goat or recoiling from a surprise face licking are common occurrences. But whatever the situation, let the kids get involved with the animals before you bring out the camera. Don't be too overt in trying to set up poses or arrange things or you'll likely steal the spontaneity from the moment.

Photographer's comments: *"My son Greg loved to walk over and see the horse every-day, and we wanted a photo of him and the pony to send to grandparents. Greg and Babe had played together before, so I took the camera to get a good picture of them. I was just lucky enough to catch this once-in-a-lifetime pose."*

Surreal Scenes

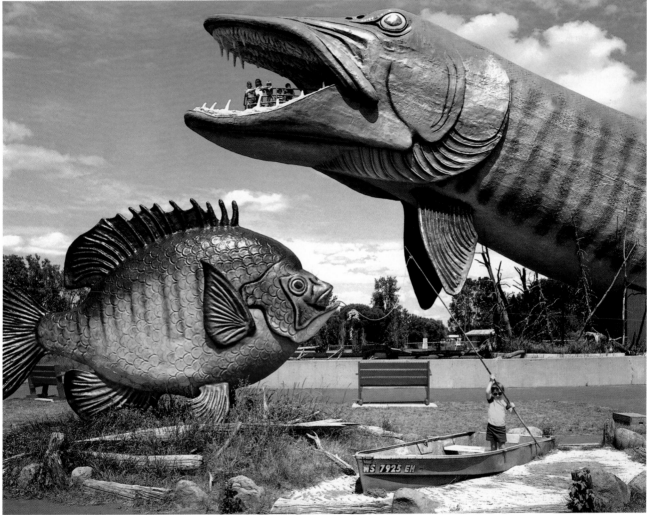

© David Graham, 1984

Sometimes reality can be stranger than the imagination. Case in point: this roadside vignette of gigantic fish that looks like a scene from every fisherman's wildest daydream (or perhaps worst nightmare). What makes the scene seem all the more outlandish is that the photographer has excluded carefully any reference to indicate why or where it exists (this display is at the National Freshwater Fishing Hall of Fame in Wisconsin).

About the only time we see fish out of water is at the supermarket, mounted on plaques and hanging on a wall, or exhibited in glass cases at a museum. In those cases, they're of normal size. Here they seem surreal.

Not only are they gigantic, but they seem to be swimming through the sky as a little boy paddles across the land.

Except for the subject matter, the photograph is straightforward; in fact, the photographer says of making the image: "It was made in the spirit of a snapshot. A climactic, agreed-upon moment." Although the spirit may have been one of "snapshot," the equipment used was not. To capture the full clarity and detail of the scene, the photographer used an 8 x 10-inch view camera—a camera normally reserved for critical commercial or serious scenic applications. The extraordinary depth of field and level

of sharpness such cameras produce helped enhance the poster-like quality of the picture.

Regardless of what camera format you use, however, there are a few simple tricks that you can employ to help hook (no pun intended) the viewer when shooting similar scenes. By including people to give the fish a sense of scale (no pun intended again), for instance, the photographer has revealed the exaggerated proportions of this scene. Also, having a boy with a proud but almost nonchalant expression posing in the rowboat enhances the "What's wrong with this picture?" effect.

LANDSCAPES

Compared to photographing many other subjects, taking landscape photographs would seem to be a completely simple and straightforward transaction. A landscape doesn't leap or scurry away, it isn't camera shy, there's usually plenty of light, and if you don't like the way it looks one day, you can always return at another time. But if you've ever snapped a breathtaking view from a scenic overlook and then wondered what happened after seeing the results, you know that landscape photography is not quite as easy as the pictures on the post card rack might have you believing.

Perhaps the most common misconception about landscape photography is the idea that the beauty of the scene will be captured automatically by the camera. After all, a sunset or a mountain is pretty spectacular all by itself—how much can camera technique or a clever photographer improve it? The truth is that in photographing landscapes, success lies not in the scene's inherent glamour or grandeur, but in your ability to articulate your interpretation to the viewer.

Another misconception among beginning landscape photographers—and one that often leads to stifling bouts of frustration—is the idea that only subjects that are grand in scale and drama are worthy of being recorded on film. In fact, scope or grandeur have little to do with a landscape's success—autumn leaves skimming the surface of a country pond can be just as enthralling as a Rocky Mountain sunset. In the photograph on page 45, for example, the photographer has found a view symbolic of the beauty of all nature in the curl of a single ocean wave.

Landscape photography is not necessarily limited to scenes of nature—or even land. Many wonderful "landscapes" have been made of the sea, clouds, and even the stars and planets at night. For those open to it, there is beauty too in the school yards and neighborhoods and industrial complexes that are such an integral—and yet overlooked—part of our daily lives. In the shot on page 48, the photographer found his landscape in a nuclear power factory.

While landscapes may appear at first glance to be static subjects, in fact they are everchanging. Changes in lighting, weather, and the seasons perpetually paint the face of the land anew. How different would the scene on page 42 look without storm clouds billowing across the sky? How less magical would the farm scene on page 40 be without the blanket of spring flowers? Although you can't control weather or seasons or light, you do have the elements of time and patience on your side. Being able to wait for conditions to improve is one of the great privileges of landscape photography.

One area in which you can exercise control is camera technique. There are a number of simple and interesting camera tricks that you can use to manipulate the mood and interpretate a landscape in a photograph. Both of the images of water on pages 34 and 35, for example, have a graceful flowing quality that exists because the photographers worked the motion of the water into their compositions by using slow shutter speeds. Similarly, in the photographs of the Amish farm scene (page 36) and Yosemite Valley (43), the photographers have used their knowledge of perspective and scale to preserve the sense of depth and spaciousness that are integral elements.

Infrared Landscapes

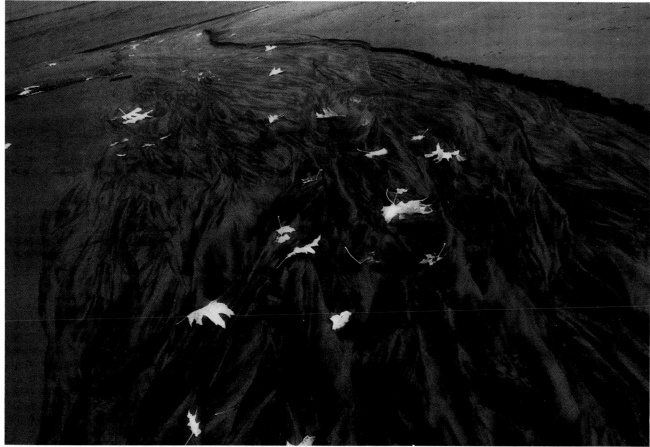

© Erv Schroeder, 1988

For many of us, the act of taking pictures, especially landscape pictures, is a way of describing our interpretations of the world around us. We've been struck by the beauty or visual intrigue of a particular place or setting and we want to share our enjoyment of it with others. It's a straightforward vision that needs only straightforward solutions.

For other photographers, physical landscapes serve merely as stepping-off points for subverting reality and exploring the landscapes of fantasy. They use their work to probe the rumblings of the subconscious in an attempt to awaken some hidden recognitions or realizations. "In my work I am engaged in an investigation of a world of my imagination," writes the photographer who created this mysterious image. "This world is self-contained and isolated. It is an escape from the temporal concerns of man and possesses the disjointed time and space of a dream."

Serious motivations, perhaps, but such innovative thinking often leads to some remarkable and bold photo-graphic imagery. Often too, it requires employing equally bold photographic techniques. To heighten the unreality of the scene above, for example, the photographer used KODAK High-Speed Infrared Film and a red filter to record only the invisible infrared radiation and block out the visible portion of the spectrum. Because you can't see infrared radiation, it's difficult to predict what the final image will look like; you'll have to experiment. However, it's exactly this unpredictability that makes it so perfectly suited to such imaginative work.

Blurred Water

Tumbling tides, rambling rivers, cascading falls—there is something about watching moving water that has a remarkably sedative effect on the human psyche. Fortunately, it's a sensation that also translates well in photographs.

In both of the evocative "waterscape" scenes here, the photographers have used a favorite technique for incorporating the natural flow of water into their photographs. The technique is easy to copy: by placing your camera on a tripod and making a time exposure, you can transform any source of moving water into a sensual, flowing "veil." The amount of blur you obtain will depend upon the shutter speed you use and the speed of the water. For slow water, such as an ebbing tide, an exposure of 1/4 to 1 second will "streak" the water; while a longer exposure of 2 to 4 seconds will entirely blur it. Rushing water, on the other hand, may become a complete blur at shutter speeds as fast as 1/15 second. To use slow shutter speeds in bright sunlight, choose slow- or medium-speed films.

Photographer's comments: *"Fall leaves and flowing water have always been favorites of mine. I prefer a 100-speed color print film with excellent color saturation for photographing foliage. I found this scene in Vermont and knew the film would reproduce it superbly."*

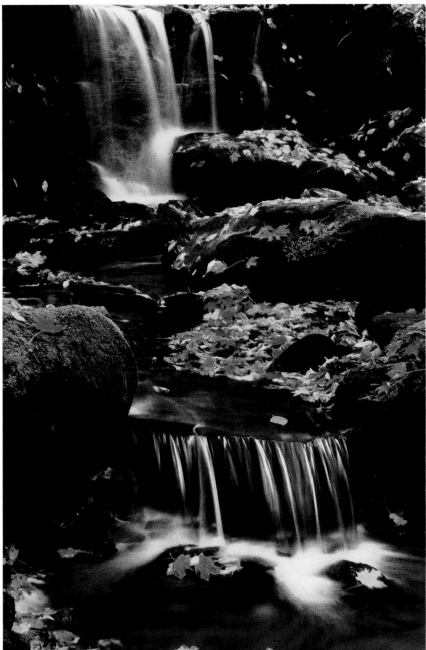

Gerard Schoenherr

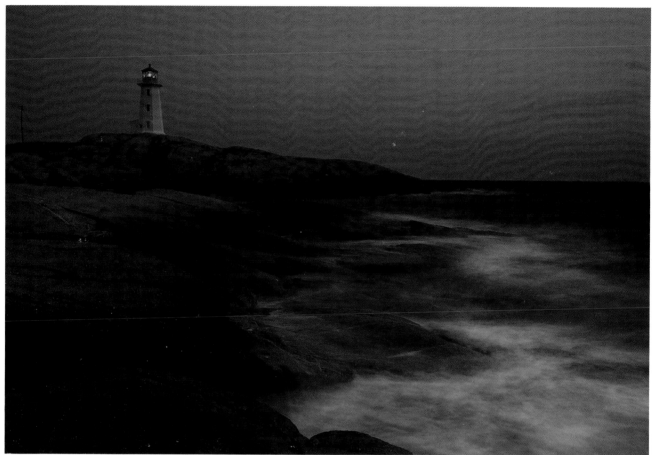

Al Sieg

Slow films (such as KODACHROME 25 Film) are ideal for such picture-taking situations because they allow you to use the necessary long-exposure times. In the dusk shot of the lighthouse, the photographer was also aided by the dim lighting which allowed him to use a very long exposure. Occasionally, though, you may find yourself in situations where the lighting is exceptionally bright, or where you have fast film in the camera and long exposures are impossible. One solution is to use a neutral density filter; these filters reduce the amount of light entering the lens without changing the coloration of the scene.

Photographer's comments: *"Seeing this place for the first time, I was impressed by the feeling of motion in the water. I wanted to create an image that transmitted some of this feeling. To provide a long exposure time that would allow portraying the feeling of motion in the water, I had to wait until well after sunset to balance the sky exposure and the water. By the way, my tripod and I were standing in a foot of very cold water!"*

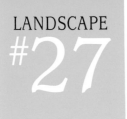
Perspective in Landscapes

Gerard Schoenherr

Because many landscape scenes—particularly broad, scenic views—take in large amounts of space, it's important that you find a way to translate that feeling of depth or three-dimensionality to the viewer. The problem is that a photograph has only two dimensions: height and width. Any visual sensation of distance has to be created by you through illusion. To establish a successful illusion of depth, you have to find a way to show that objects exist both near and far in the frame. You can do this most easily by using any of several known depth indicators or "cues."

Among the most immediately recognizable indicators of depth is linear perspective—the apparent convergence of parallel lines as they recede from the camera. Lines that begin near the front and converge to a point at the back of the scene create a powerful sensation of distance. In this Amish farm scene, the photographer used the sweeping convergence of the rain-slicked road to dramatically enhance the feeling of spaciousness. In addition, by using the road as a leading line, the photographer has drawn our attention immediately to the farm at the end of the road.

Often, you can intensify the effects of linear perspective by using a wide-angle lens to exaggerate the diminishing sizes of objects (the horse carts here, for instance) from near to far, and heighten the front-to-back convergence of the lines.

Photographer's comments: *"Some would say 'forget taking pictures in the rain.' On this day it was pouring. The most useful accessory was an umbrella. But with the right exposure—and the right subject—rain can create outstanding color results."*

Composition in Landscapes

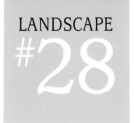

In composing a landscape photograph, one of the first things you have to decide is whether you want to make a vertical or a horizontal picture. With the exception of square format cameras, most cameras formats (including 35 mm) offer a rectangular frame that's considerably wider in one direction than another, and the way that you choose to hold the camera will make a huge difference in the visual impact of the picture. Sometimes the choice of framing is obvious: Much of the interest in this Brazilian neighborhood scene, for instance, comes from its steep vertical inclination. To frame the scene horizontally would destroy the inherent power of the composition. Similarly, you would probably want to use vertical framing to exaggerate the height of a towering waterfall or a giant redwood. But the framing question is not so obvious or definitive with all subjects: A city skyline photographed horizontally might emphasize its vast expanse, while a vertical composition would dramatize the height of its buildings. Often the only answer is to photograph a scene both horizontally and vertically and see which looks better after you have your pictures processed.

Bear in mind also that your choice of framing will have some effect on the more subliminal interpretations of your pictures; horizontal compositions seem to impart feelings of stability, while vertical pictures appear more dynamic and powerful.

Neil Montanus

Photographer's comments: *"The unusual, vertical composition of these houses in Brazil caught my eye. The stairway next to the houses allowed me to include people in the picture to give a sense of action and movement. It also shows the size relationship of the houses."*

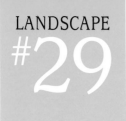
Famous Landmarks

Joseph Janowicz

Famous landmarks provide a somewhat double-edged opportunity for landscape photographers. On one hand you have the grandeur of an inherently spectacular scene to inspire you to new heights of creativity. On the other hand, you're photographing a subject that has been photographed thousands of times before. You will have to go some distance artistically to come up with an original interpretation.

It's not impossible to come up with new ideas on a familiar theme, but it takes imagination, planning, and hard work. Read how the photographer describes the effort that went into getting this shot of Egypt's famous pyramids at sunrise: *This picture was made in Cairo, Egypt at 5 a.m. Now, that's not too early for a sunrise— except that I had to get up at 3 a.m. to drive to the location which was miles away. I arranged for the two camels and riders to meet us at 4:30 a.m.. It was pitch dark when they arrived. Since I couldn't speak their language and all they could say in English was 'Hello, you want ride?,' I had to jump up and down and point to get them into just the right position. They understood, and just as the sun came up I got the picture.*

Most of us don't have the time (or the inclination) to go to such great lengths to get one picture when traveling. But before settling for the standard post-card view of a famous scene, consider what you can do to make your pictures more original. It may mean shooting the Brooklyn Bridge with night traffic or hiring a local guide to find you a perspective of the Taj Mahal that isn't in the tourist books, but the extra effort you make will mean the difference between just one more shot of a great landmark and a great shot of a great landmark.

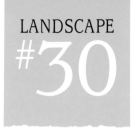

LANDSCAPE
#30

Visual Anchors

Something often lacking in otherwise successful landscape pictures is a strong center of interest—a specific element or part of the broad expanse that grabs your eye and holds your attention. A scene of rolling hills draped in autumn colors is attractive, but without a focal point it offers little for the eye to linger on. Include a hang glider or a horse and rider atop the hill, however, and you provide that visual anchor.

A center of interest doesn't have to (and generally shouldn't) dominate a landscape composition. Rather it should be the one element that holds the composition together both visually and thematically. In this early morning lake scene, the fisherman and boat are small, yet the eye gravitates toward them immediately.

Knowing that such small elements can have terrific visual impact means that you have to place them carefully in the scene. The initial temptation is to put your center of interest right in the middle of the frame. Usually, though, this only serves to chop the rest of the photo in half and creates a very stagnant composition. Instead, frame the subject off-center and use other elements within the frame to balance them (when needed) the way the sun and fisherman offset one another in this scene.

Philip G. Lisik

Country Landscapes

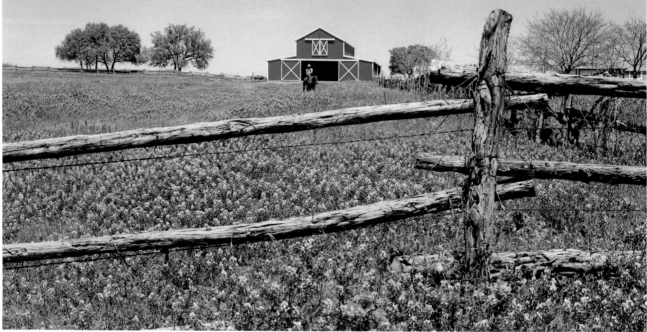

Norm Kerr

There is something innately picturesque about rural scenes and country settings that seems to hold an irresistible appeal for landscape photographers. If you're like many photographers, that promised land of cherry-red barns and silver-topped silos is one of the first places you head when the urge to take pictures stirs. Far removed from the hustle and daily pressures of city or suburban life, such settings offer feelings of tranquility and renewal that few other subjects can rival.

But before you begin popping away at calendar-perfect cliches, take time to analyze your feelings about the rural environment. If neat fields and tidy farmhouses are your interpretation of the country landscape—fine. Accent their orderly nature by using carefully planned compositions and clutter-free viewpoints. Be particularly careful to avoid any intrusions from the high-tech world (a distant high-voltage tower) that will spoil their "untouched" appeal. Perhaps, though, your perception of the country is less pastoral. If so, look for the tumble-down sheds, rusting tractors and vine-covered privies that are also a common part of the rural landscape. In their decay they tell an eloquent tale of a rapidly-fading way of life.

In either case, unusual lighting and weather conditions can add considerable drama to such scenes. If you see a scene that appeals but the lighting is mundane; make note of the location and return another time. You may want to take along a polarizing filter to increase the color saturation of the sky. While this farm scene with rustic fence would probably be attractive at almost any time, the the blanket of spring flowers makes it particularly appealing.

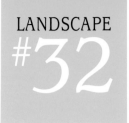

Electrical Storms

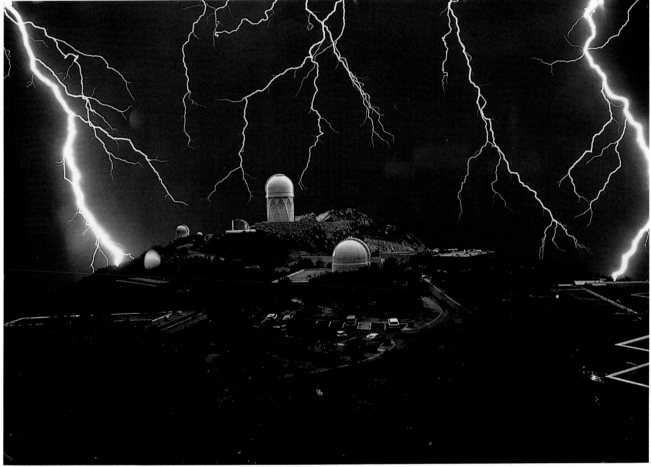

© Gary Ladd, 1972

Lightning is a thrilling natural phenomenon to witness—and twice as exciting to photograph. With 1,000 thunderstorms sparking across the earth at any given moment, photographing lightning may seem easy. But in most parts of the world, lightning does not often display itself as ideally as these numerous, branching bolts. So when sensational lightning does appear, you'll have to be ready.

Spectacular as lightning is, your pictures will be more interesting and offer a truer sense of scale if you compose your shots around an interesting foreground subject—a hilltop church, a dead tree, or an interesting skyline, etc. Decide on the spot ahead of time, because if you wait until the storm is upon you, you'll spend your time frantically searching for a location instead of shooting pictures.

You can photograph during any time of day or night—although nighttime storms offer you more exposure flexibility. For both day and night shots, use a medium-speed color negative film, such as 200-speed film. In daylight, set your lens at its minimum aperture (usually f/16) with the shutter set to B and with a cable release, hold the shutter open until several bolts occur. Timing and luck play a big part in daytime lightning photos; if the shutter remains open too long, you'll overexpose the picture. At night, set the lens at f/5.6 and lock the shutter open for several minutes—or until a number of bolts have flashed across the sky.

Most importantly, follow the well-known safety rules about electrical storms. Don't stand outdoors in an open area during a storm. Photograph through the window of a building or your car—and photograph only distant storms.

Photographer's comments: *"I had started working as a research assistant at Kitt Peak Observatory a few months earlier and wished to capture the raw power of the lightning on this stormy night. Luck was with me. The film shows a scene which cannot be experienced otherwise—the duration of the flashes is too brief for the eye and mind to appreciate at the time of exposure."*

Landscape Moods

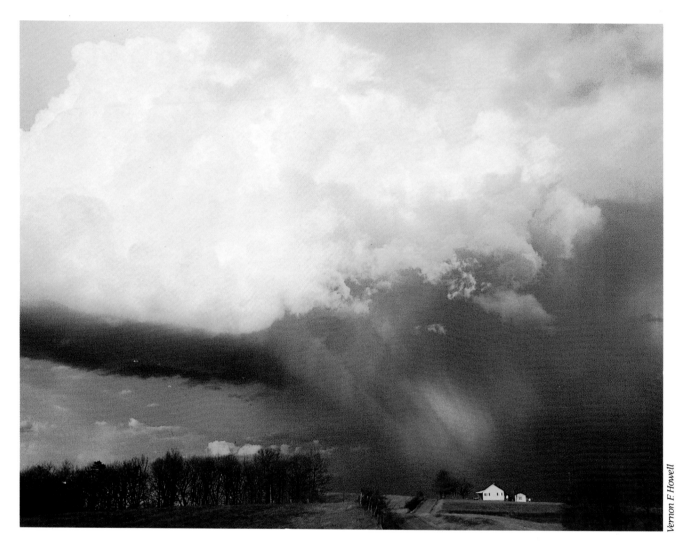

Vernon F. Howell

City streets or mountain vistas, nothing alters the appearance or the mood of a landscape quite as profoundly as drastic changes in the weather. Thunderstorms, in particular, are powerful sources of drama and excitement; in the blink of an eye a scene that once was basking in a calm sun is suddenly churning into fury. Getting out there and capturing this drama on film can be as thrilling an experience as the storm itself.

You can best photograph storms either as they approach or depart. The gathering darkness of a thunderhead as it shrouds a country village or the gleaming arrows of sunlight parting the black canopy of the dissipating storm often give you the most spectacular opportunities. During the height of the storm, you're likely to be assaulted by rain, hail, or even lightning, so take care to protect yourself and your equipment. Do not stand outdoors in a lightning storm.

In composing storm scenes, look for subjects and angles that heighten the tension of the moment. In the scene above, by using a distant vantage point and a wide-angle lens, the photographer has captured the explosive magnitude of the storm and also exaggerated the remoteness and isolation of the lone hill-top house.

Photographer's comments: *"This photo was taken on a photographic field trip in order to gain more subject matter for my work as an artist and art teacher. I saw the thunderstorm approaching and found the nearest ridge road heading in its direction. My intention was to capture the turbulent storm in contrast with the sunlight landscape. I used a wide-angle lens to capture the magnitude of the incoming clouds."*

Scale in Landscapes

Standing in front of a spectacular vista it's easy to comprehend (or at least have an inkling of) the vastness of the subject you're dealing with. There are people, trees, birds, and other objects of known size that allow you to get some concept of the spaces involved. Very often in taking pictures of such subjects, however, those indicators are cropped—and along with them goes all indication of true scale. Without a sense of scale, much of the grandeur of the view is lost in the photograph.

To re-establish the true magnitude of a panoramic scene, it's important to include some object of known size as a reference in the photo. People are probably the best standard of measure since everyone knows their approximate size. In this view from the crest of Half Dome in Yosemite National Park, the photographer found an inventive way to show scale by using his own feet as foreground. The feet not only provide a quickly-identifiable sense of proportion, they give the viewers a compelling and breathtaking sense of immediacy that places them on the edge of the cliff. Other people included on a nearby ledge provide additional clues to the distances involved.

Photographer's comments: *"After viewing the sheer face of Half Dome from Yosemite Valley, and then hiking all the way to its summit, it was hard to resist peering over its edge. I wanted to end up with a picture that described the scale of the rock, the extreme exposure at its summit, and my presence there—in a physical sense, rather than just implied through the camera's point of view."*

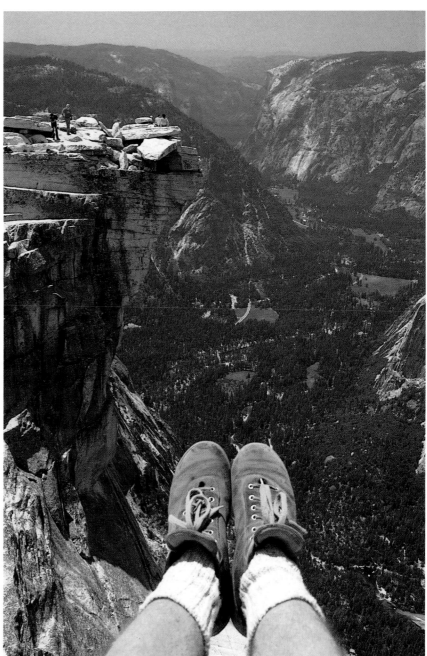

John Green

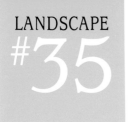

People in Landscapes

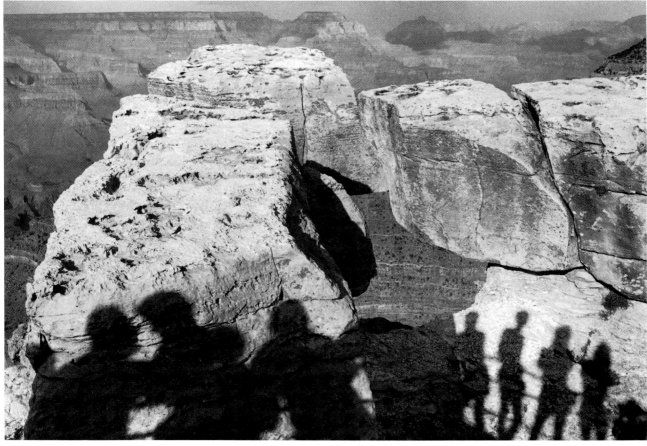

Mark Nicholson

Deciding whether or not to include people in photographs of great natural wonders is a question that most landscape photographers encounter sooner or later. Ironically, many 20th century landscape photographers, faced with a diminishing wilderness, take great pains to exclude any signs of human activity; while 19th century photographers, confronted with a virgin, American wilderness, often included people to give scale and a human element to their landscapes.

Should you include people in your scenic photos? Is a photograph of a pristine winter wilderness less pure if there's a cross-country skier in the composition? Or does that skier help link the viewer emotionally to the scene? Only you can decide and usually you'll have to do it on a picture-by-picture basis. In this photograph, the photographer has made imaginative use of the presence of man by including the shadows of tourists viewing the vastness of the Grand Canyon. For those so inclined, much symbolism and social commentary could be read into the image ("shadows of mankind across the wilderness")—though others may simply see the shot as a clever take-off on a familiar tourist view. Either way, the photographer's presentation is an attention getter.

Landscape Details

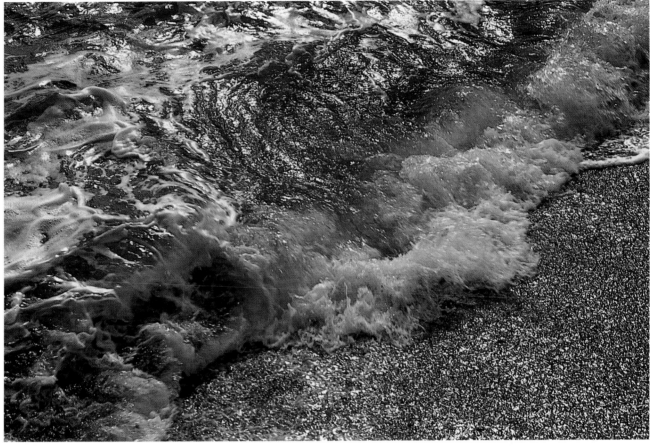

Francoise Bouillot

Not every landscape photograph has to read like an epic novel—some can do very well as short stories. Too often photographers spend energy trying to harness the broad panoramic view and they overlook the details. Yet within every large landscape are a thousand smaller ones waiting to be discovered. Lily pads shining on the surface of a pond, a sprig of dogwood against the sky, or a cluster of weathered headstones in a New England cemetery—each can be just as picturesque as a wider, more expansive view.

What details make interesting pictures? Sometimes you'll be inspired to find a landscape-in-miniature by something as simple as a texture, such as velvety row of moss-draped rocks at the river's edge. Other times you may find interesting patterns within a landscape; rather than shooting the whole corn field, zoom in on a section of freshly cut furrows. To capture the glimmering photo here, the photographer consciously overlooked the grander possibilities of a full-fledged seascape and instead chose to isolate an intimate glimpse of tide and sand.

Seasons

© Michael J. McNamara

Winter, spring, summer, and fall—changes in the seasons have a way of rejuvenating even the most dulled and jaded of photographic spirits. Just when the sameness of summer is about to steal away your last breath of enthusiasm, along comes autumn, igniting the face of land and fanning the flames of your fading inspiration. Accustomed as we are to the turning of the seasons, the magnitude of the magic and beauty that they bring never fails to take us by surprise. The bleak days of January could give no hint of the profusion of flowers that lay beneath this church yard waiting for spring. In photographing seasonal landscapes, it's important to keep from being so overwhelmed by the season's beauty. Do not ignore the need for a provocative subject or the fundamentals of creating a good landscape: interesting composition, a strong center of interest, and skillful camera technique. Instead, look for ways to emphasize the subject's relationship to the particular time of year. In composing the scene here, for example, the photographer has carefully chosen his viewpoint to exaggerate the flamboyance of the floral ground cover. The intense, midday lighting—usually a bane to landscape photographers—further heightens the radiance of the flowers and gives a spring-like brightness to the picture.

In all seasons, remember that the most intense beauty is usually short lived. So if you see an eye-catching scene, seize your opportunity—it's unlikely to still be there later if you procrastinate.

Photographer's comment: *"Finding a great scene to photograph is often as simple as making the right turn on a back road. You never know what you'll find. But if you keep an open mind, it's always an adventure. I used a 28 mm lens and a polarizing filter to capture the rich colors of the flowers and sky, and used KODACHROME 64 Film."*

Simple Landscapes

If there is one trait common to successful landscape and scenic photographs, it is simplicity. Far too often photographers scramble to cram every last detail into the frame, only to confound the viewer and diminish the impact of the main subject. But landscape photographs don't depend on quantity for their success; rather, they depend on selectivity.

In the simple but powerful view here, the photographer has chosen only three elements—dune, sky and clouds—to convincingly render the harsh desert landscape. By shedding all extraneous surroundings and concentrating on a single dune, attention is riveted on the abstract pattern of windswept sands and their near-mirror image in the clouds. There is no confusion about what the photographer wanted us to see.

Still, such simplicity of design is far more easily appreciated than it is created. You must make a conscious effort to determine the essential elements and to emphasize them through viewpoint and lens choice. Most importantly, move closer to fill the viewfinder, or aim higher or lower to place the main subject against a simple background. If it's physically impossible to change your point of view, use a zoom lens at several focal lengths to sample a variety of potential compositions.

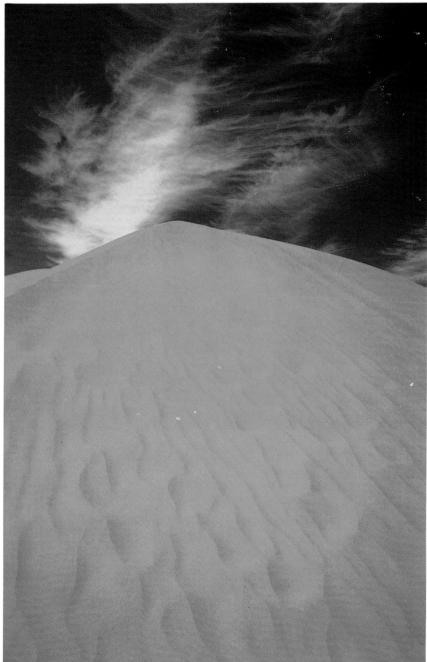

Gary Whelpley

Photographer's comments: *"I often look for simplicity, but also abstract visual elements to photograph in nature. This view of sand dunes in Monument Valley is simple but abstract. The sidelighting delicately adds texture to the foreground sand. The white cloud against the blue sky gives me the feeling of steam coming out of a volcano."*

Industrial Landscapes

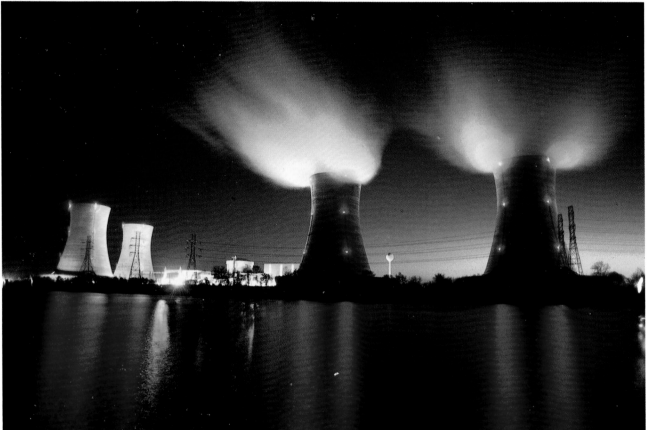

© Volker Hinz, 1986, A Day in the Life of America

While it is often passed over for more traditional or aesthetically appealing subjects, industry has an undeniable visual intrigue. From the rust and rubble of aging steels mills, to the science-fiction-like settings of nuclear power plants, industrial landscapes are rife with complex collections of shapes and alien looking structures that are just waiting to be photographed. Pictures of industrial compounds are all the more interesting because they provide a fascinating glimpse into settings that we see every day, yet they often look foreign in design.

Like natural landscapes, most industrial settings have a particular mood that is distinctly their own—a shipping terminal has a far different flavor than that of a rock quarry. The more you visit a location, and the more you know about it, the more you'll gain a feeling for its special atmosphere. Try to find a viewpoint or a special technique that helps capture that feeling. For example, by photographing the nuclear power plant at Three Mile Island using a long time exposure at night, the photographer has captured splendidly the haunting nature of the environment. The luminous aura surrounding the cooling towers, combined with false-color artificial lighting around the base of compound, enhances the mystery.

When photographing any industrial location, be sure to ask permission first and observe safety procedures. Many sites have insurance policies that forbid non-employees to enter the location. Always work from a safe distance to ensure your safety.

Underground Landscapes

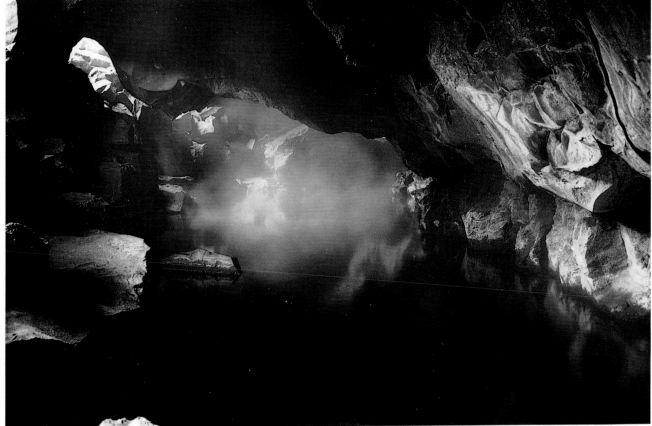

Bruce W. McLaughlin

Though we tend to think of landscape photographs as being made above the surface of the earth, some enthralling, scenic pictures have been made in the seldom-viewed underworld of caves and caverns. Unless you are an experienced spelunker, however, you will have to confine your underground explorations to guided trips in large caverns or readily accessible caves such as this surreal lava cavern in Iceland, which is filled with steam from a thermal pool.

While some surface caves may be lit by shafts of sunlight, most tourist caves have been artificially illuminated to dramatize geologic features. In either case, the light level will be extremely low requiring the use of a fast film, such as 1000-speed film. If you are taking a guided tour of a large cavern, bring a small tripod or monopod to steady the camera for long exposures and try to position yourself at the end of the tour group so that you aren't constantly being hurried along.

Also of great importance is protecting your camera from the hostile subterranean environment. Sand, water, humidity, mud, and airborne dust are constant companions lurking in even the friendliest of caves. For short trips, a tight-fitting camera case will do; for longer excursions keep your camera in a self-sealing plastic bag until you're ready to shoot. When on any excursion, take time to enjoy the scenery while exploring with your camera; all picture-taking experiences should be fun.

Photographer's comments: *"This lava cave in the Myvatan nature preserve in northern Iceland is filled with a natural hot pool reaching 60° C. Not only was it a good place to get out of the cold rain, but the steam rising from the hot water glows nicely in the shafts of sunlight, lending a sense of softness to the otherwise stark and hard environment."*

LIGHTING

While the subjects we photograph are an essential part of the picture, it is light that creates the photograph. On a basic, practical level, light is the illumination that allows us to take pictures. On a creative level, it is in light that the photographer finds his closest confidant and his fondest muse. It is light that carves, shapes, and colors the world around us and light that can turn the most familiar of settings into an unusual picture. Yet, for all of its wonder and power, many of us give light little consideration when it comes to planning a photograph.

It's easy, when searching for the perfect barn or a spectacular mountain peak, to become so involved in composing and focusing the scene to ignore the quality of the light. We simply take a meter reading, and then shoot. But light is more than a sufficient illuminator, it is the language of photography. It is a language that can shout in its drama, or whisper in its intimacy. But in order to speak that language fluently, you must become a student of its many guises and moods.

Since most of the photographs that we take are made in daylight, the best place to begin your study of light is with the sun. From the first crimson glimmer of dawn until the last violet glow of twilight, daylight is in a constant state of flux, continually altering the appearance of the world around us. And though our brain is pretty good at smoothing over and disguising theses changes, you can observe and exploit them if you know what you're looking for.

That daylight changes in direction, is fairly obvious. As the earth twirls on its axis and skitters its course around the solar system, the position of the sun relative to trees, barns, and mountains changes. And as the direction of light striking a subject changes, so does the appearance of your subjects. Sidelight (page 55), paints the world with texture and shapes it with form. Backlighting (page 58), with its long shadows and raking highlights, adds depth and brings an ethereal luminosity to transparent subjects. When backlight is very intense it creates a rimlight effect (page 53) that decorates the edges of objects and outlines them against their surroundings.

Less noticeable perhaps, but equally important, are changes in the color of daylight. It is the color of light more than anything that sets the mood of a photograph. Green light cools, red light incites passion, and yellow light lures us with its warmth. Another quality of light that affects mood is its intensity. Compare the flamboyant excitement of the cathedral interior (page 51) to the quiet intimacy of the woman doing laundry (page 57) to see how persuasively changes in the light's intensity can alter the mood and appearance of a scene.

Of course, the sun is far from being the only source of photographic lighting. Nighttime provides us with a whole new world of lighting possibilities—from the ribbons of neon lights to the twinkle of stars in the midnight sky.

Do not think that you are limited to taking pictures only with existing light. In the inventive scene of chess players (page 61), the entire composition was created by the photographers using flashlights and electronic flashes.

In the gallery of scenes that follow, the common thread is the keen observation of light on the part of the photographer. As you study the pictures, try and see how each different type of light could be adapted to subjects that you photograph frequently.

Dramatic Lighting

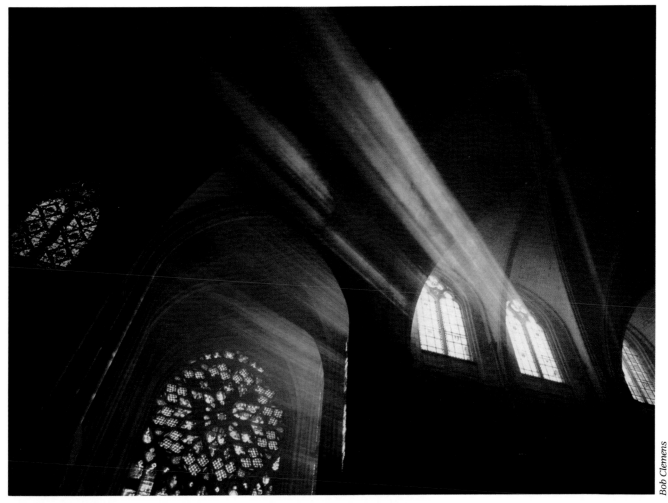

Bob Clemens

Nothing incites photographers like the high drama of sunlight's spectacular displays. Few among us could enter such a theatrically-lighted cathedral and not make a panicky fumble for the camera? And while such resplendent lighting might seem rare, in reality the melodrama of light is a storyline played out a thousand times each day, on countless stages both grand and common.

Surprisingly, the appearance of dramatic lighting can be predicted frequently. Anyone familiar with this cathedral in Sens, France, for example, would know that at a certain time of day during certain seasons, rapturous blades of light will burst through the vaulted windows almost on schedule (an effect planned undoubtedly by the architects).

Even your house or apartment can yield dramatic lighting. Look for shadow patterns from window mullions or Venetian blinds cast onto a wall, or the low, winter sun spotlighting a vase on an end table. When working indoors, use a high-speed film, such as 1000-speed film for color prints.

When the lighting is in transition, it is another good time to expect visual drama. What more spectacular display than the sunlight that briefly gilts black-as-night storm clouds at the end of a storm?

Taken advantage of, certain ordinary types of lighting can also appear highly theatrical. A good example is the first rays of sun igniting a morning meadow with fiery backlighting. Always though, such moods are fleeting, so be prepared to work quickly with your camera.

Photographer's comments: *"Light is the essence of photography. This photograph dramatically shows light giving substance, shape, and beauty to the dimly-lit interior of an ancient French cathedral."*

Twilight

Twilight is one of the prettiest times of day to look for photographic opportunities. Scenes made in daylight's last lingering glow have a moody atmosphere that piques our sense of romance and imagination. The approach of night combined with different subjects can be used also to kindle a wide variety of emotional associations. A twilight scene of a suburban street, for instance, might be viewed as the serene end of a long day; a city street in the same light might be interpreted as slightly sinister or perhaps exciting.

Whatever the effect you're after, the usable period of twilight is brief, so plan your photo in advance and be prepared to work quickly. Because the light is dim, you'll need to use a fast film, such as 400-speed film, or enlist a tripod to support the camera for longtime exposures. Often too, you may find yourself working in silhouette, shooting a shadowed foreground against a brightly colored sky.

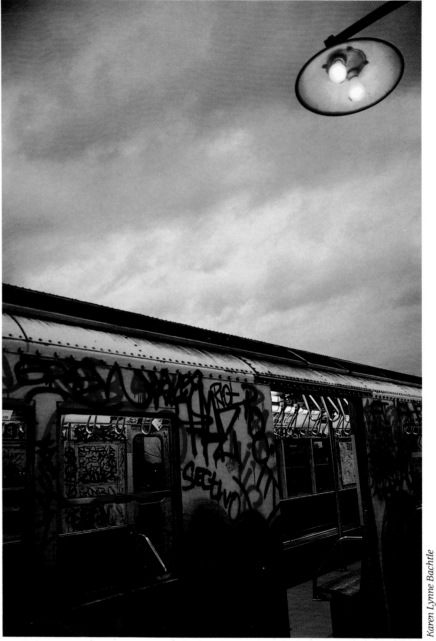

Karen Lynne Bachtle

Rim Lighting

Rulon E. Simmons

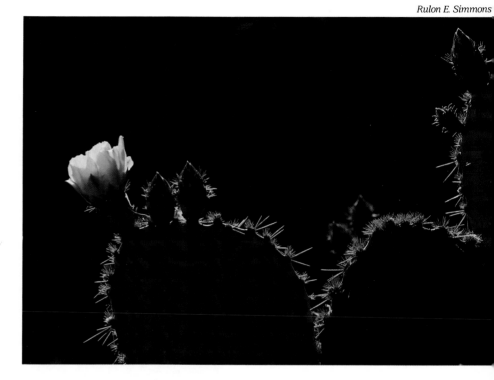

If you've ever stood talking to someone while his back was toward a brilliant, late-afternoon sun, you've probably noticed the halo of bright light around his hair. In photography, this luminescent fringe is called "rim lighting" and it's a favorite technique among portrait photographers. It also works well with close-ups of flowers, particularly when the subject has some light-colored or translucent detailing around its edges. Here it highlights the blossom of a prickly pear cactus because the blossom is the largest, translucent part of the subject. But, the lighting also emphasizes the cactus spines, which most people readily identify with a cactus.

Rim lighting is most conspicuous when the background is dark and the subject is lighted from directly behind and slightly above. Unless you own a spot meter, metering for rim-lighting is difficult at best. One solution is to meter a larger area of brightness similar to that of the halo of light and shoot at that exposure. Keep in mind, however, that this will place the subject itself in near or total silhouette—as it did with this cactus close-up. If you choose an exposure that will make the subject a silhouette, be sure that the halo outlines your subject entirely or some of the subject may merge into the dark background.

If, on the other hand, you want to retain some foreground detail (in a portrait, for example), open the lens about two stops from the meter reading you got from the bright area; but be aware that too much extra exposure may wash out any detail in the halo. Another alternative is to keep the exposure set for the highlight and use fill flash or a white cardboard reflector to brighten the front of the subject.

Photographer's comments: *"I keep my camera handy when I am on vacation. During a vacation that took me through Texas, I came across this prickly pear cactus. I liked the beautiful backlighting on the blossom which I emphasized by photographing the flower against a shaded background. I used KODACHROME Film for this picture, as I do for most of my nature photography, because of its extreme sharpness."*

53

Sunrises

Like snowflakes and fingerprints, no two sunsets or sunrises are ever alike and each seems more captivating than the one before. For photographers, recording such splendid dramas is like being a child set free in a toy store—it's difficult to decide where to begin grabbing the prizes. Fortunately, because sunsets and sunrises are so pretty, it's hard to come away with an uninteresting picture. Still, there are some hints that can help you catch that ever-elusive quintessential sunscape.

To give added appeal to the picture, find a center of interest such as a tree or a barn or a person strolling on the beach. Sun and clouds are enjoyable, but they can become repetitious and boring. If the sun itself is particularly brilliant, position yourself so that it's behind the subject (as the photographer did here) or wait until it slips behind a cloud. A bare sun often overpowers the image with flare—though this too can sometimes be effective.

You can often combine a sunrise with morning mist or fog to create a dreamlike effect. After a summer evening rain, rise early the next morning to see if fog has formed.

Remember too, the sun never appears nearly as large on film as it appears in person. Use a telephoto lens (200 mm to 400 mm) when you want to suggest the enormity of that glowing red orb as it sets behind the horizon. And if you use a long lens, use a shutter speed at least equal to the focal length of the lens or, better yet, mount the camera on a tripod. Long lens or short, don't take a light meter reading aiming directly at the sun as it will cause underexposure.

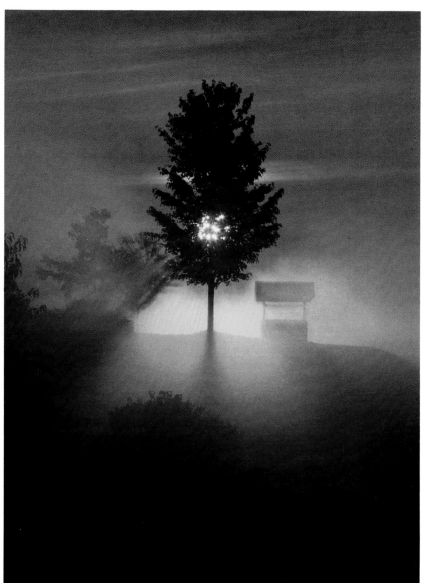

Alan Siracusa

Aim your lens towards a bright area of sky just away from the sun and use this meter reading.

And very importantly, never stare directly into the sun with or without your camera—it can cause irreparable eye damage.

Photographer's comments: *"I photographed this tree at sunrise after a very cool night. My intent was to combine the dramatic lighting with the morning mist to capture this soft, dreamlike effect."*

LIGHTING
#45

Sidelighting

Like backlighting, illumination that comes from just one side of a subject often reveals features and qualities that are rarely noticed in full front-lighting. With the gentle touch of a sculptor molding a work of art, side-light explores the sensual forms and intricate contours of the physical world. The carving "hand" of sidelight-ing reveals the more subtle, tactile qualities of a subject; here, for example, scruffing the horse's coat and delineating its neck and ears.

Finding or creating sidelighted situations is relatively easy because all you have to do to go from full front-light to sidelight is move your camera position (or your subject) 90 degrees. The best times to look for existing sidelight are early and late in the day when the sun's rays are low. As the bil-lows of this horse's breath reveal, one bonus of early and late light is the soft warmth of its color.

By nature, sidelighted (and back-lighted) scenes are unusually con-trasty and it's rarely possible to record completely both highlight and shadow detail. If shadow detail is small and trivial, a meter reading that averages the different brightnesses should provide good overall exposure, while still leaving some detail visible in larger, open shadows. If shadow detail in deeper shadows is important, take a close-up reading aimed directly at the shadow or open the lens aperture 1 to 2 stops from the full-scene reading.

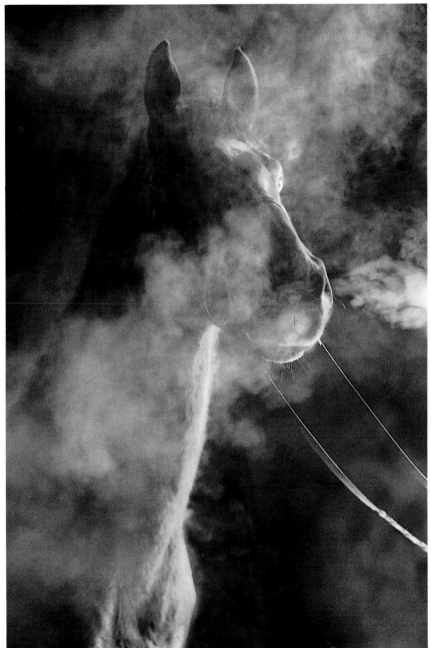

Alan Siracusa

Photographer's comments: *"On a number of occasions I've witnessed this steam being given off by horses on cold days after a hard workout. After several failed attempts, I captured this unique photograph with the use of sidelighting. I also timed this shot to capture the additional steam given off as the horse exhaled through his nostrils."*

Afterglow

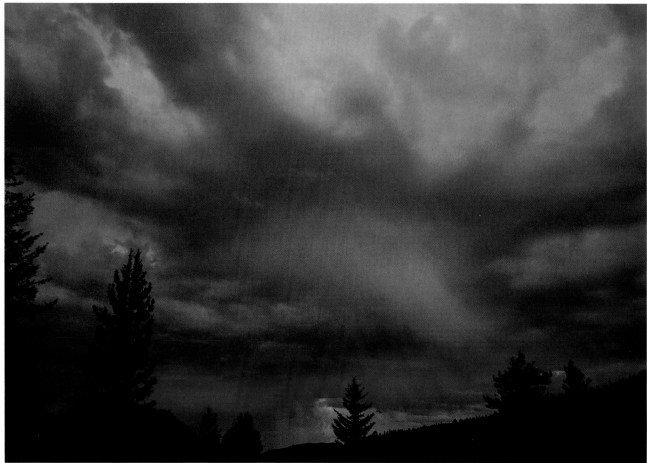

Betty Meyer Witt

When you're photographing sunsets, don't use all your film too soon. Like a great symphony, such natural dramas sometimes save their surprises until the finish—or in this case, the encore. For a few moments after the sun has set below the visible horizon, the sky often ignites with a final, brilliant crescendo of afterglow: Clouds surge with color; still waters gleam with reflected light; and the land responds with an eerie luminosity. The photographer used a polarizing filter to increase the color saturation of this photo, taken after a storm in Rocky Mountain National Park in Colorado.

Like sunset photos, afterglow shots work best with some foreground (usually in silhouette) to frame the scene. But choose a low angle to emphasize the sky and clouds. If a lake or pond is in the scene, find an angle that will allow you to capture the sky and the reflection of it—or ignore the sky entirely and shoot just the reflection. Exposure for afterglow pictures is trickier than sunset/sunrise pictures because there's not as much margin for error. When you use films for color slides, it's best to meter the brightest area of cloud and then bracket one or two stops over and under that reading. Finally, don't forget to turn away from the sky to see how this special light is coloring the landscape around you.

Photographer's comments: *"I enjoy looking at the sky in its various moods—especially the unique cloud formations. I captured the striking beauty of this sky at sunset following a storm in Rocky Mountain National Park in Colorado."*

Window Lighting

One of the most eloquent and yet often ignored sources of daylight exposure for photographs is window light. Interior scenes photographed solely by the light of one or more windows generally impart a warm, cozy ambiance that electronic flash or other artificial lighting destroys. The mood of the ordinary scene showing the woman doing laundry is enhanced by the warm, window light.

In composing window-lighted scenes, you may have a choice of whether or not to include the windows. One of the problems of including them is contrast. Sunlight streaming in from outside usually overpowers dimly lighted interiors, forcing vexing exposure decisions. If you expose for the interior, the window and any outside detail washes out. If you expose for the bright area of the window, the interior falls into deep shadow. A compromise exposure between the two may work, but usually it's simpler to avoid contrast problems by working on overcast days, or finding an alternate composition that eliminates the window from the scene.

Occasionally the combination of including a brightly lighted window and exposing for the dimmer interior can create a dramatic backlighting effect—as in the scene of the woman doing laundry. The aura of daylight engulfing her hair and figure heightens the intimacy and warmth of the picture. In metering such scenes, however, take care to exclude the window from the viewing area so that the meter won't overcompensate for the brightness and cause you to underexpose the interior detail.

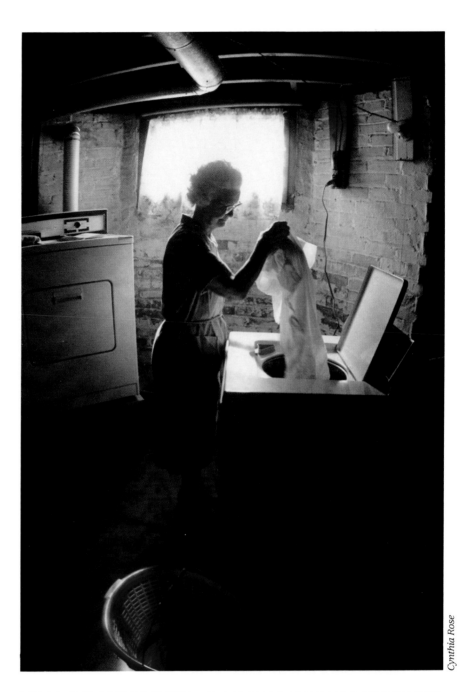

Cynthia Rose

Photographer's comments: *"I am interested in the beauty of everyday life. In this scene, the time of day, the surroundings, the color all created towards the whole effect of a photo I felt should be taken. I shot in early morning with light shining directly in the window and used a fisheye lens to capture the entire setting."*

Backlighting

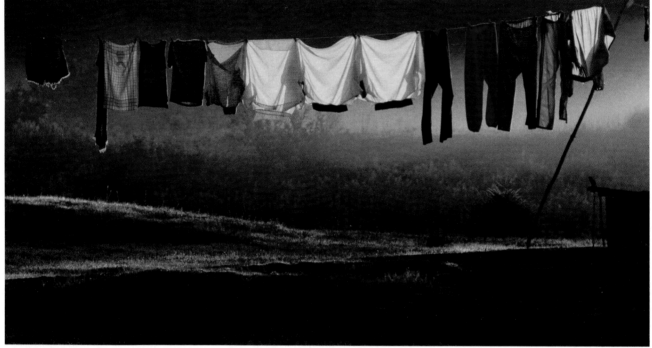

Peter A. Marr

One of the first rules we all learn in photography is to keep the sun over our shoulder and shoot with the direction of the light. Nice dependable frontlighting—it provides safe, easy exposure and good, clean color. But as this wonderful image shows, you sometimes can break tradition and shoot directly into the light source to provide some exciting and unconventional results. Indeed, without the exuberant backlighting and the early-morning mist rising from the field, it's likely that this photographer would have overlooked this scene.

You can exploit backlighting to create many useful and creative effects with a variety of subjects. In broad scenic views, for example, elongated shadows created by backlighting can enhance the apparent three-dimensionality of a scene. Backlighting also enhances the color satu-

ration of translucent subjects, such as leaves, flower petals, and sails. However, if portions of the scene are opaque, such as a tree limb, you may want to give the picture two additional stops of exposure to provide some shadow detail. Or, you can use fill flash. As with rim lighting, keep in mind that this extra exposure may wash out the bright highlight areas of the scene.

With any backlighted subject, be particularly careful that the sun's rays do not spill directly into the lens: You risk degrading the image with lens flare. In addition, your camera's meter may interpret the scene as brighter than it really is and grossly underexpose the picture. To help prevent this from happening, use a lens shade on the front of the lens when shooting into the sun.

Photographer's comments: *"This picture represents the combination of two of my favorite picture elements, namely clotheslines and early morning atmospheric fog. I prefer backlighted situations and this added to the drama in this photograph. To me this is one of my most successful pictures, and one that I keep coming back to look at."*

Nighttime

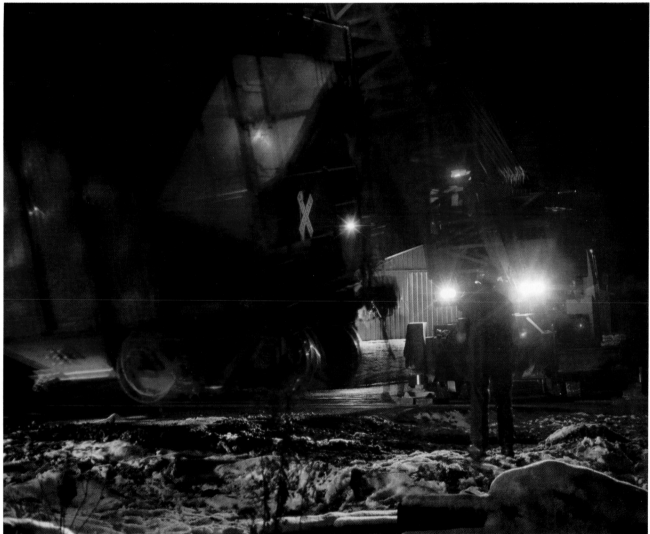

Pete Poremba

If you limit your outdoor picture-taking to predictable daylight situations and put your camera away when night falls, you're missing half the fun of photography. From neon signs flaring off rain-slicked streets to summer carnival rides swirling in the evening sky, the nighttime world brims with its own vibrant colors and electric excitement. Pictures made by existing light at night have an untamed energy that doesn't exist in the daytime. With fast films such as 400-speed or 1000-speed films, almost no nighttime scene is out of reach.

One difficulty you will encounter with existing light shots is color balance. All color films are matched to a certain light source: daylight films are balanced for daylight, for instance, and tungsten films for tungsten lamps. But lighting at night can come from any number of unusual (and often mixed) sources—mercury vapor, neon, arc lights—so it's usually impossible to predict exactly what your final pictures will look like or how close your colors will be to reality. Color slide films require more critical handling than color negative films because the latter can be color-corrected in the printing stage.

You can use light-balancing filters to match a particular film to another light source, but again, you first have to know specifically what kind of light you're working with. Make your life easier: stick with a daylight film that you like and let the off-beat lighting chart its own creative color course.

Shadow Play

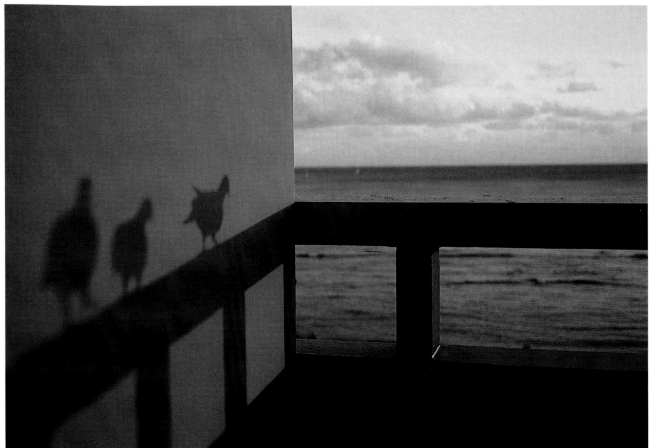

P. Tamara DeRosa

Sometimes the best way to show the presence of light is by photographing shadows. By creating a means of comparison, shadows often intensify the apparent color or brightness of a particular light source. You can photograph the subject and its shadow or just the shadow alone. Photographs that capture the shadow and not the subject are especially intriguing because, like silhouettes, they leave to the imagination everything but the shape of the subject. There is a fun and somewhat mysterious quality to the shadows of these pigeons that would probably be lost in a photograph of the birds themselves.

Shadows are especially plentiful early and late in the day when the sun is low in the sky and everything on the surface of the earth is in the path of its light rays. Also, because the sun's rays have to travel a much greater distance through the atmosphere during early morning and late afternoon, the light has an attractive pastel quality that often contrasts nicely with shadows. Even though the sun itself is out of the frame in this scene, the warm, pinkish tinge on the nearly neutral wall gives the picture an especially cozy feeling. It also tells us that the sun has just risen or is about to set. Shadows generally have a much more open and gentle appearance at this time of day.

Photographer's comments: *"I really like the illusion of the birds captured by their shadows and the aesthetic aspect of the entire scene. I set out food for the birds on the ledge at the far end of the balcony. I fed them on a daily basis, so they were accustomed to coming there for food and also got used to me walking near them. Then I waited for the right moment to snap the shot."*

Painting with Light

© *Peter Donaldson & Garry Gay, 1988*

Of all the techniques discussed in this chapter, perhaps none is quite so eye-catching or as open to creative possibility as that of painting with light. Actually, painting with light is a term that covers a number of different but related techniques. To create this ingenious and intricately colorful light fantasy, the photographers employed two techniques: painting with flash and flashlight tracing.

The chess players (and some background details, including the window frames) were created using flashlight tracing. Basically, you accomplish this technique by outlining a subject in total darkness using a pen-size flashlight. By dressing your subject (and yourself) all in black, only the beam of the flashlight will record on the film. In these examples, the photographers embellished the technique even further by using different colored gels over the flashlight lens. The intensity and width of your flashlight tracings will depend on several factors, among them: aperture size, brightness and size of the flashlight and the speed of your tracing motion. The slower the motion and/or the brighter the beam, the wider the tracing will be and vice versa.

Painting with electronic flash, which was the technique used to color the background, can create some dazzling results. You'll need a portable flash unit that allows you to fire it manually and some colored gels to fit over the flash. The "painting" is simply a matter of popping the flash at the background wherever you want color. The colors will be more intense and have more purity if you use a white background; but you can also build up intensity by making multiple flashes in the same area. By overlapping two or more colors of flash, you can also create some interesting color mixtures.

Photographers' Comments: *"This is a painting-with-light technique, capturing many individual moments on one piece of film. Since such pictures require long exposures, they allow for a real collaboration. We like to think of them as Performance Pieces for the camera."*

NATURE

Nature is probably the most photographed of all subjects after people. From the innocent charm of wildflowers tossing in a spring breeze to the sudden fury of animals battling in the wild, we are simply captivated by nature. And through photography we can not only express our personal fascination, but we can also share it with others.

Much of nature's allure comes from the fact that, in all of us, there exists a shared sense of wonder and mystery at the power, complexity and beauty of nature. Nature photographs succeed best not when they offer mere botanical or biological records, but when they awaken an emotional response in the viewer—whether it's fear at the onslaught of a violent storm, or awe at the untold and rarely viewed secrets of the life beneath the seas (page 67).

Although nature is a boundless supplier of interesting subject material, you will probably find success faster if you attach your ambitions to an area or subject that holds particular fascination for you. Two of the most popular and challenging areas of nature photography are close-up photography and wildlife photography. While each area has its own special technical and aesthetic considerations, neither is beyond the ability of any photographer willing to learn a few simple techniques and exert some extra effort.

Close-up photography is a fascinating world of its own. It's hard to believe sometimes the wilderness of wonder that lies beyond the magic looking glass of the close-up lens: tiny insects, ordinary at first glance, suddenly are full of interesting detail. A garden spider's lair becomes a feat of architectural design. Once you begin to investigate the world of the minuscule, you'll never look at a moth, a mushroom, or a leaf in the same way again.

The chief requirement in making close-up photographs is, of course, magnification. But close-up accessories need not be expensive to give good results. Least expensive (about $10) are close-up filters which come in several powers of magnification and simply screw to the front of the lens. Extension tubes, that fit between camera and lens, are another inexpensive solution. More advanced equipment includes macro lenses and macro-zoom lenses.

Wildlife photography may be the most exotic—and most difficult—

area of nature photography. Animals are by necessity shy creatures and will rarely sit still to have their portraits made. But you can approach them—if you know how and when. Contrary to popular myth, you don't have to jet to Africa or the Amazon to find suitable subjects; the suburban wilds are filled with animals, both majestic and exotic. The owl on page 74 was photographed only a few miles from the photographer's home, as were the deer on page 70.

Remember too, while it's exciting to capture a clear picture of any animal on film for the first time, the best wildlife photographs are those that provide an intimate glimpse into an animal's lifestyle and behavior. The best wildlife photographers, therefore, are those who take the time to get to know their subjects' personalities, their terrain, and their habits. Even a simple field mouse has routines; knowing them can unlock the invisible gate to his kingdom.

In the following pages we'll explore some remarkable nature photographs of subjects both common and extraordinary. As the pictures and comments will show, the primary qualification for success in any area of nature photography is one that you probably already possess: a love of the outdoors.

Closeups of Wildflowers

One of the great pleasures of photographing wildflowers is that you need never look further than your own yard or a nearby woodlot to find a host of new and interesting subjects. Flowers provide enough diversity of color, shape, and pattern to keep even the most prolific of photographers occupied for a lifetime.

Because maintaining sufficient depth of field is a constant struggle in close-up photography, you'll need to work with the smallest f-stops possible. But small f-stops mean correspondingly slow shutter speeds, and at speeds of 1/30th or slower, even the slightest breeze will blur your subject. There are three possible solutions: use a medium- to fast-speed film (such as 200-speed film); use a sheet of art board (or an old umbrella) to erect a temporary wind block; or use electronic flash as the photographer did in this portrait of Fringed Gentians.

Another concern is choosing the best point of view. Obviously, you can show a flower from only one angle at a time, so it's important to choose a viewpoint that you feel reveals one or more of the plant's outstanding physical characteristics. But don't concentrate on one blossom or one plant so much that you miss other picture possibilities. In the photograph of the Arethusa, the photographer has found a novel solution to revealing both back and front views of the same species by backing off to photograph two similar blossoms (at different angles) in the same frame.

Also, don't get so enthralled by your subject that you ignore background and lighting. Dark backgrounds—shadows or tree stumps, for example—are best for accenting color or shape, and are less distracting than busy backgrounds. Lighting coming from the side or behind the plant will

Antonia LoSapio *John W. Adams*

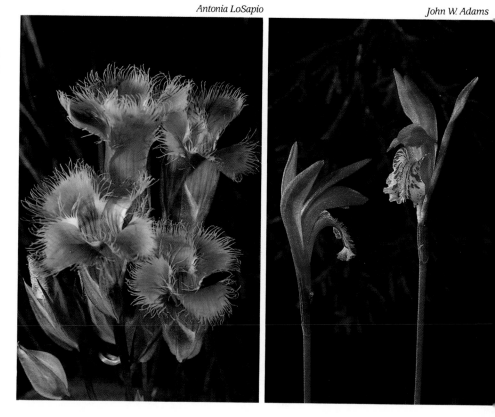

show delicate surface textures and help reveal the translucent quality of the petals. If you can't get the sun where you want it, or the day is overcast, use a small electronic flash held a few feet off-camera to simulate sunlight. The short duration of electronic flash will also freeze virtually any motion.

Photographer's comments: *"When I photograph nature subjects, I study them for a while first and pick out what I consider to be the most interesting feature. Then I move in close and try to show off that special feature. For example, in this picture of the Fringed Gentians, I added backlighting to bring out the interesting fringe along the edges of the flowers. I also used EKTACHROME Film to bring out the blue color. Exposure was 1/60 at f/16, with three electronic flashes."*

Photographer's comments: *"A very small percentage of people are able to view this bog orchid in its natural setting. This specie is not widespread; it grows only in certain bogs (such as Bergen Swamp in Rochester, New York); the flowering season is short and it is about five inches tall. So even if you know where they grow, it's not an easy task to locate them. It's a very exciting feeling to find one flower—but to find two together is rare. To show the detail, color, and splendor of this flower to others is one of the important features to me of nature photography. I think nature's handiwork is to be shared."*

Mother and Young

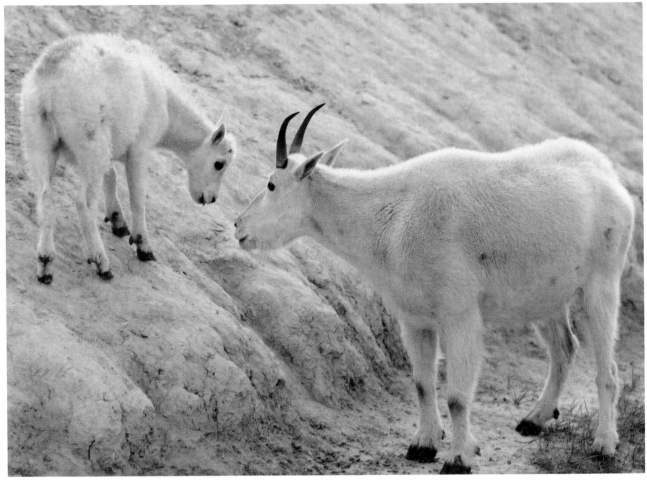

Peter A. Marr

Regardless of how well you get to know any animal's habitat or lifestyle, most wild animals—particularly more remote ones like these mountain goats—will let you approach only to a certain invisible perimeter. Once you move inside this circle of protection, their behavior becomes wary and they may flee or even become aggressive. Animals will stick around longer and behave most naturally if you work from a distance that they consider to be safe, which usually means using a very long telephoto lens.

The composition in this picture is strong. The photographer waited until the two goats were face-to-face, with the smaller one peering down towards the other. When photographing small or large groups of animals, it can sometimes be difficult to find them positioned exactly the way you want. Often the herd will be shuffled in different directions. For this reason, it's good to move in close with the aid of your telephoto lens and isolate only a few animals.

For most medium to large animals, lenses with focal lengths of at least 300 to 500 mm are required to provide a good image size from a relatively great distance. Lenses much shorter than these don't provide the necessary magnification. But long lenses are heavy, slow (in terms of maximum aperture), and expensive. As a lighter (and less expensive) alternative to owning extreme telephotos, you can buy tele-extenders that fit between camera body and lens and multiply the focal length of your existing lenses by a specified magnifying power. (A 2X extender, for example, converts a 300 mm lens into a 600 mm lens.) Extenders do rob some light (one to two stops) and edge sharpness, but the losses may be minor compared to the convenience gained.

Imaginary Creatures

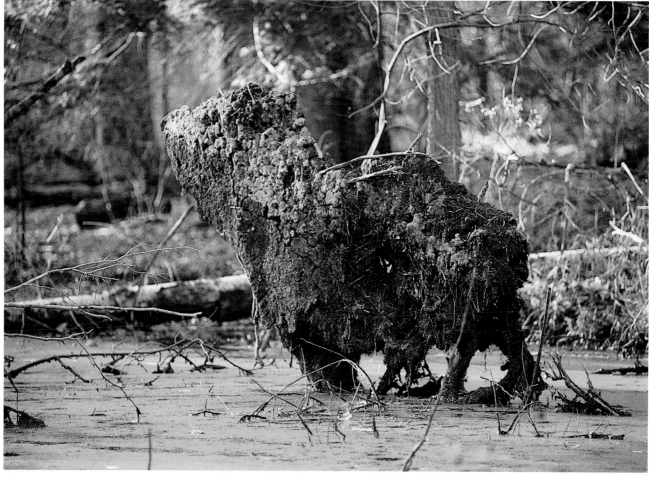

Thomas J. Barron

Nature can be full of weird, wild, and off-beat picture opportunities. But seeing them requires an open mind. In the woods, especially, it's easy to get so involved searching for the perfect fungi or stalking an animal that we miss many of the more unpredictable possibilities that surround us. But keeping the avenues of imagination clear and being open to the unanticipated is part of what nature photography is about. In the somewhat darkly-humorous scene above, for example, the photographer was observant enough to spot the likeness of a decaying swamp creature in an upturned tree stump.

A good way to dispel your preconceptions or preoccupations—particularly in a new environment—is to walk and observe the locale without taking your camera out of the bag. While the isolation of the viewfinder is a technical blessing in composing pictures, sometimes it can create a false tunnel vision that limits observations. You're more likely to spot interesting designs or chance happenings if you're involved in exploring the rhythm and personality of a place. Opening yourself to new subject ideas is also a good way to relieve frustration when the specific subject you have been trying to find or photograph hasn't materialized. Don't let the hawk that got away get to you—go with what's around you. When you are relaxed and receptive, interesting picture opportunities will often find you.

Early Winter

Finding interesting, natural compositions in spring or summer is easy—the sun is warm, meadows are in bloom and it's generally a pretty and inspiring atmosphere for creative picture-taking. But when the chilly winds of fall and winter blow away the warm summer breezes and the fields frost with snow, it's another story. Finding nature subjects in the dead of winter may be more challenging, but may also be more rewarding in some ways. With the once blossoming fields and woods now bare, you may notice new signs of wildlife that were previously overshadowed. Animal tracks in the snow, fallen berries, and the staunch brigade of barren trees may offer new motivation for picture taking.

You'll discover that nature doesn't disappear in winter. Life and the rhythms of growth and change are slowed, but they continue—and there are traces of past and future life all around you. A yellowed maple leaf drifting on a bed of snow, for instance, perfectly symbolizes the seasonal rites of passage. You needn't look for such profound symbolism to make good pictures, however, because the winter world is full of intrinsic beauty: swirls of ice in a frozen stream, frosty weeds frozen in their decay, or an entire woods laden in a fresh snowfall are all good subjects.

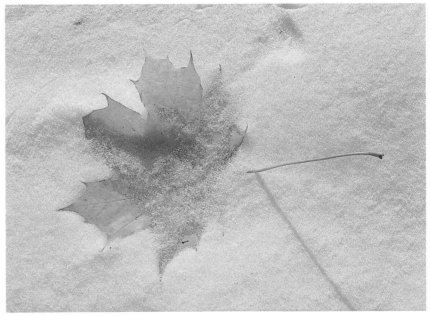

John W. Adams

Exposure for snow and frost requires care. Underexposure by one or more f-stops could cause you to lose the crispy clean whiteness; with a half stop or more of overexposure, you may lose the detail of texture. A good solution is to take your reading from an 18-percent gray card (or any medium-toned subject) and use that setting. When in doubt, go by the exposure data printed in the film box and bracket your exposures. Take an exposure at the reading called for by the camera's meter, and take one with the lens opened one stop and one with it closed down one stop.

Photographer's comments: *"As the seasons change there is an overlap from one to the other and I discovered one interesting relationship. An early snowfall brings winter as the leaves continue to fall. This scene was in my backyard and it illustrates that we don't need exotic trips to take pictures. Timing is also important for many nature photographs. It is true for the yellow leaf, as the early snow soon covered it, giving me but a few minutes to take the photograph. Procrastination is the photographer's greatest enemy."*

Underwater

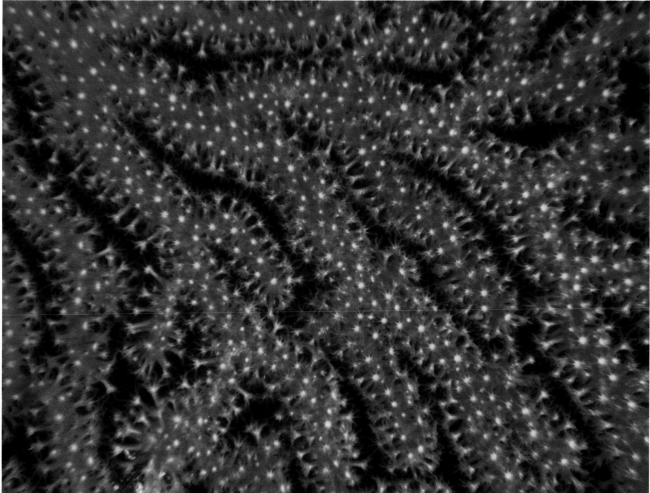

Marijan Richter

Photographing underwater is simpler than you might imagine. Snorkeling is probably the easiest way to attempt underwater photography. If you're vacationing in a tropical or subtropical climate, snorkeling will bring you face-to-face with a variety of colorful corals (like the red coral shown here), exotic fishes, anemones, and a host of other wondrous creatures all within a few feet of the water's surface.

For equipment, you have some inexpensive options for shallow-water photography. One choice is to buy a plastic-bag housing for your existing camera. A popular style has built-in gloves for operating controls and is safe to depths of about 30 feet. You can also use some of the new all-weather cameras at similar depths. In many popular resort places like the Caribbean, you can usually rent both simple and sophisticated underwater gear at diving or sailing shops.

The biggest technical problems you'll encounter underwater are light and color loss. At depths of 10 feet or less, light is usually quite bright and colors will record on film nearly as you see them. But as you aim at subjects at depths of 20 to 25 feet (even if you're positioned in shallow water), light intensity drops off sharply and the red end of the spectrum all but disappears. You may want to use a red correction filter to restore proper coloration at such depths.

If all this sounds a bit daunting, take heart; there's much sea life to be photographed in shallows and in tidal pools—and you don't have to get more than your feet wet.

Creative Backgrounds

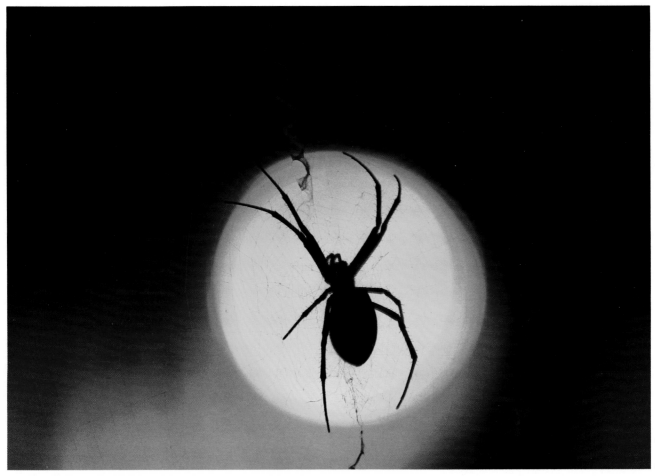

Larry Lauszus

Used creatively, backgrounds can play a powerful role in close-up pictures. Early and late in the day, one exciting background you can experiment with is the sun itself. By photographing this garden spider against the glowing orb of a setting sun, the photographer created a scintillating close-up portrait that at once reveals both the intimacy and the vastness of the natural world.

Technically, the most important thing to remember about using the sun as a background in closeups is that you'll have to work at the lens' largest aperture to keep the sun's image large. If you select a small aperture, you'll make the sun seem smaller. Also, because you'll be shooting directly into a bright sun,

your camera may not have the fast shutter speeds necessary to use such large apertures. To overcome this, you may want to use a very slow film such as KODACHROME 25 Film for color slides and, if necessary, neutral density filters over the lens to reduce the light reaching the film.

Careful framing is essential. It's the exact centering of the spider over the sun's image that makes this photo so eye-catching. In composing the scene, remember that the greater the magni-

fication and the closer you're working to your main subject, the larger the out-of-focus image of the sun will be in comparison to the subject. You may have to move closer or farther away from your subject to keep it correctly framed. Or (as was the case here) you can use a zoom lens and alter the subject-to-sun size ratio by changing focal lengths. Also, take care not to look at the sun directly through the viewfinder; it could cause eye damage.

Photographer's comments: *"My neighbor asked me if I would take a picture of her spider which she had watched grow to maturity. With my 80-210 mm zoom lens in its macro setting, and using a tripod, I shot directly into the setting sun with the spider framed against the setting sun."*

Animal Aggression

For all of the violent life-and-death drama that takes place in the animal kingdom, ferocity and aggression are relatively rare commodities in most wildlife photographs. The reason is simple: It's easier (and a lot less dangerous) to photograph an animal when it's napping or quietly grazing than when it's baring its fangs. But passive poses make for static pictures. Photographs that show animals as they growl, snarl, tumble, tear, and claw have a bold and unmistakable authenticity. Although both photographs here were made in the wild, you can photograph similar scenes in most zoos.

You'll find the best action either late at night or in early morning. During midday most animals conserve energy by napping. Early and late in the day are the times when most animals prowl for food and when they're most active. (Even in zoos, animals are much more active at feeding time.) The brown bears shown here were photographed in late afternoon as they battled over rights to a fishing spot along a river in Alaska.

Of course, outright confrontations are not the only source of exciting animation; sometimes a warning growl—like this cheetah's angry warning to the photographer—or just a threatening pose or tense posture can imply action or power.

In the wild, the danger and unpredictability of animals should never be underestimated. Scenes of violence and power must always be photographed from a distance with telephoto lenses, and you must always remember that you are the intruder—the aggression that they aim against another can be redirected just as quickly toward you.

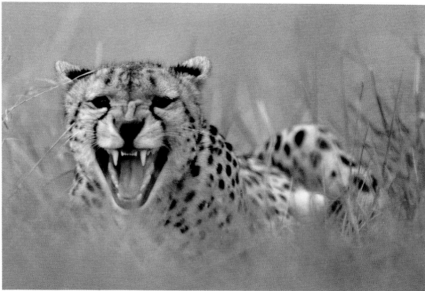

Neil Montanus

Photographer's comments: *"During a safari on the Masai Mara National Reserve, Kenya, we spotted a full-size female cheetah. The open jeep gave us a good view of the animal as it stalked off into the high grass to lay down. My driver carefully maneuvered to within 50 feet of the cheetah. I slowly climbed out of the vehicle and lay down behind the rear tire. Placing a bean bag on the ground, I nestled the camera with a 300 mm, f/2.8 lens on the bag. I managed to squeeze off three shots as the magnificent animal growled and began to move toward me. You can bet I beat a hasty retreat into the jeep for a safe getaway."*

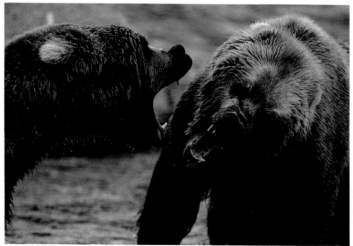

Gary L. Lackie

Photographer's comments: *"I take many, many wildlife photos and bears are my favorite. I went to Brooks Falls near Katami, Alaska for that reason, to photograph bears. Equipment: 35 mm SLR camera, 400 mm, f/2.8L lens w/1.4 extender. KODACHROME 64 Film shot at 1/500 second at f/2.8."*

Elusive Animals

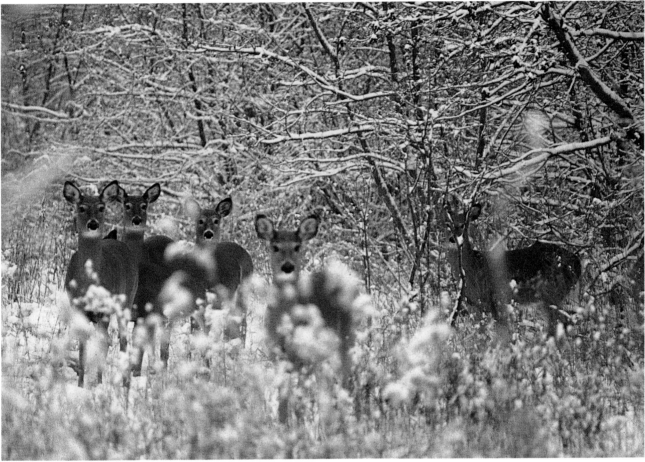

Alan Siracusa

Frozen in alertness, in setting and on film, a herd of white-tail deer tenses at the click of the camera's shutter in this timeless wildlife portrait. Swift, silent, and graceful, deer are among our most common wilderness neighbors, roaming even the borders of outlying suburbs. They are also one of the most elusive subjects in the wild—so elusive that even in heavily deer-populated areas, sightings remain an unexpected delight.

For these reasons, scenes such as this one then are rarely stumbled upon. Capturing them on film requires planning, patience, an element of luck and, perhaps most importantly, a knowledge of wildlife habits. The best ways to acquaint yourself with the range and routines

of a particular species are to read wild-life or hunting magazines and talk with local park rangers or conservation officers. Better yet, you can acquire the knowledge firsthand by being out in the field and woods. Feeding or drinking areas, such as an old orchard or a stream, are often good locations. Know when to seek out your subjects. For deer, the best time of day is early morning, when they venture out to feed. The best season is late winter when they usually collect in herds and can be readily

tracked in the snow.

Even with a good understanding of your quarry's lifestyle, most animals are far too skittish to let you approach very close unless you take some special precautions. Your clothing should be drab and blend well with your surroundings: greens in spring and summer, browns or hunter's orange during the fall hunting season. As much as possible, walk upwind of your intended target; if you're spotted by an animal, pause until it resumes its normal behavior.

Photographer's comments: *"My intent in this photograph was to depict white-tail deer in pristine and wonderland-like surroundings. With the help of a heavy snowfall and the knowledge that deer yard up during severe weather conditions this photo took on a unique quality. They became very alert due to the noise of my shutter release."*

Insects

Dipped in the sparkling dew of dawn, a dragonfly clings motionless to a thistle and waits for the warmth of the morning sun to dry its wings. Few of us tire of seeing such intriguing scenes, but you won't capture them lying in bed. Such rewards are offered only to those willing to seek out their subjects during the fleeting, early morning interlude when daylight and insect mobility are briefly synchronized.

Exotic as such images seem, they are relatively easy to find. At dawn you'll find dragonflies, bees, and butterflies perched on grasses in meadows and along pond and stream edges. Chances are they'll be too cold to move, so you can take your time to compose the perfect scene. Later, when the sun has dried them off to fly, you'll have opportunities as they sun themselves on a favorite leaf or plant stalk. After finding several dragonflies, the photographer chose this one because it was "perched on something colorful and situated against a dark, subdued background [that would show off the dew]." But they're also creatures of habit and will often land repeatedly on the same perch, giving you many opportunities to photograph them if you remain patient and immobile. Once warmed up, dragonflies are alert and wary, and will zip off at your slightest movement.

Even with cooperative insects, you'll need to work quickly. You can better your chances of taking several good shots by prefocusing on a likely spot and waiting for your subject to come into view. You can use selective focusing to isolate the insect from the background, and you may need to use a faster shutter speed to stop the movement of the wings. To allow fast shutter speeds, choose a high-speed film such as 1000-speed film. If you find that long shutter speeds are unavoidable, even with the use of a high-speed film, you can augment the existing light with a portable flash unit instead, or use a small white card to reflect sunlight onto the subject.. If you anticipate making enlargements, use a slower, fine-grain film and supplemental lighting for proper exposure.

This photographer used a 200 mm macro lens at f/22 for this photo. Use a telephoto or zoom macro lens so you can work at a greater distance and not disturb the insect. If the image does not appear large enough in the viewfinder, you can also add an extension tube between the lens and camera, to shorten the focusing distance so you can move in a little closer.

Dean Pennala

Photographer's comments: *"I consider myself a nature photographer. I went exploring on a cold, dewy morning and found several dew-covered dragonflies. I chose to photograph one perched on something colorful and situated in such a way that I could feature a dark, subdued background. I used a 200 mm macro lens at f/22. Lighting was early-morning open shade with a clear sky overhead. Film was KODACHROME 64."*

Shore Birds

Few birds are as inherently handsome as the sleek and elegant snowy egret. Ironically, the very beauty of this shore bird once drove it to the brink of extinction. Hunted widely in the 19th and early 20th century for its fashionable plumes to adorn hats, the species—now hunted only with a camera—is once again a common visitor to beaches and marshes from Maine to the Gulf of Mexico.

Wading birds and other large shore birds make good subjects for budding bird photographers. In addition to being relatively tolerant of human company, their large size and carefully measured movements make them far more accessible than smaller (and more skittish) songbirds or more aloof birds such as eagles.

The best time to photograph waders is when they are hunting early or late in the day. Absorbed in their chores and knowing that one move on their part may scare an unsuspecting fish, they will often let you approach within a few dozen yards without moving. You will most likely have to use a telephoto lens to bring the subject closer, such as a 400-800 mm lens. If you are very stealthy, it is possible to get close-up shots with only a moderate telephoto (135 mm to 210 mm) lens. The trick is to move closer a few feet at a time, remaining still for several minutes between movements. If the location is affected by tides, try working when there's an incoming tide, so that the birds are being pushed toward you, rather than moving away.

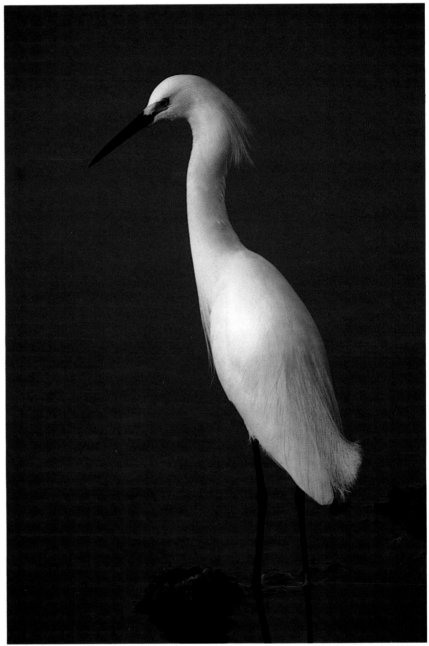

Rulon E. Simmons

Photographer's comments: *"Most bird photography requires the use of long lenses. I use a 400 mm lens on a tripod or other support for most of my bird photography—as I did with this snowy egret. Wildlife refuges such as Ding Darling National Wildlife Refuge on Sanibel Island, Florida (where this bird was photographed) are excellent places to photograph birds."*

Patience

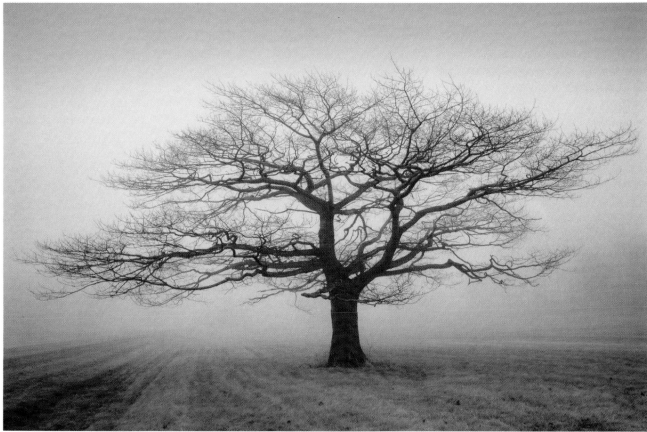

Gene Schaible

Though bright sunny days are good for capturing a cheerful, postcard rendering of a landscape, inclement weather can help you better interpret the true essence of a place. Fog, in particular, is a deft weaver of mystical moods and evocative spells. Drifting through the countryside, fog strips most color, detail, and texture from its path. But what it robs from realism it more than pays back in atmosphere.

On a more practical level, you can use fog to isolate interesting shapes or objects from distracting surroundings—as with this lone, hilltop oak. Without the fog, the flowing lines of the tree might have been obscured in the surrounding hills or their strength diminished by competition with other secondary subjects.

But remember, beware of subject distance: The farther you move from your main subject, the more intense the fog effect becomes.

One inherent difficulty of working with fog is exposure. Because fog is highly reflective, it tends to trick light meters into causing underexposure. You can compensate by opening the lens aperture one stop from the meter's reading.

An important element of this photograph is the photographer's patience and habit of remembering remarkable subjects. The photographer first spotted the tree on a clear day and was impressed by its shape. But he knew that the background clutter would detract from the tree. When a spring fog settled in, two years after he first noticed the tree, he knew it was time to make the photograph.

Photographer's comments: *"I prefer subjects that are dramatically illuminated by natural light. But some subjects—like this oak tree—can be more effectively presented in diffused lighting. I first noticed this tree two years ago and felt that its majestic form could best be represented if the background clutter was obscured. On a recent Saturday, my patience was rewarded when a heavy, spring fog settled over the area and the lighting I had anticipated was just right."*

Saw-Whet Owl

Considering they live most of their lives under the secretive cloak of night, owls would seem to be an impossibly reclusive target for photographers—especially in broad daylight. But the real problem isn't so much in overcoming their shyness, as it is in knowing how and where to find them. After all, this tiny (about six inches tall) saw-whet owl allowed the photographer to approach within four feet! She used a 200 mm telephoto lens with a supplemental tube between the camera and lens to allow a closer minimum-focusing distance, and an electronic flash.

Again, the more you know about an animal's habits, the more likely you are to make contact. Hunters by night, the common saw-whet owl is an extraordinarily sound sleeper by day (so sound, in fact, that they often won't wake when approached). Like most owls, saw-whets prefer dense conifer cover and sometimes live in abandoned woodpecker nests or hollowed trees. The best way to discover favorite roosting spots is to search the ground under spruce or pine trees for owl "pellets"—the undigested fur and bones that owls regurgitate.

Even in daylight, however, owls are likely to choose the darkest, most dense parts of a forest, making electronic flash virtually a necessity. Fortunately, most birds and animals interpret flash as lightning and aren't alarmed (though they may not be so tolerant of a clunking shutter).

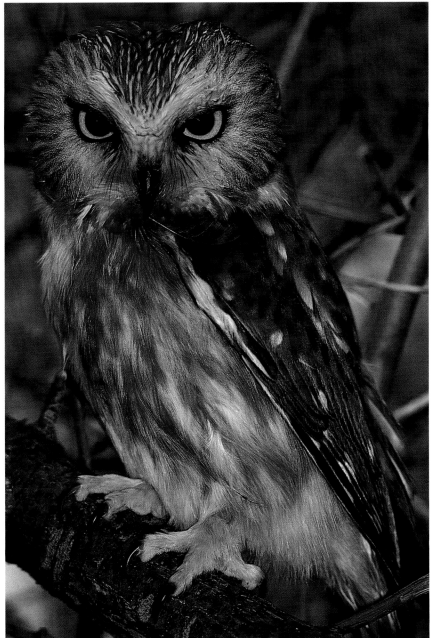

Antonia LoSapio

Photographer's comments: *"I was so excited to find this little guy that my adrenaline was flowing as I shot the photo. Everyone asks: 'How were you able to get so close?' Actually saw-whet owls are very tolerant of humans and the easiest of all owls to photograph. Exposure on KODACHROME 25 Film was 1/60 at f/8 using electronic flash."*

Action

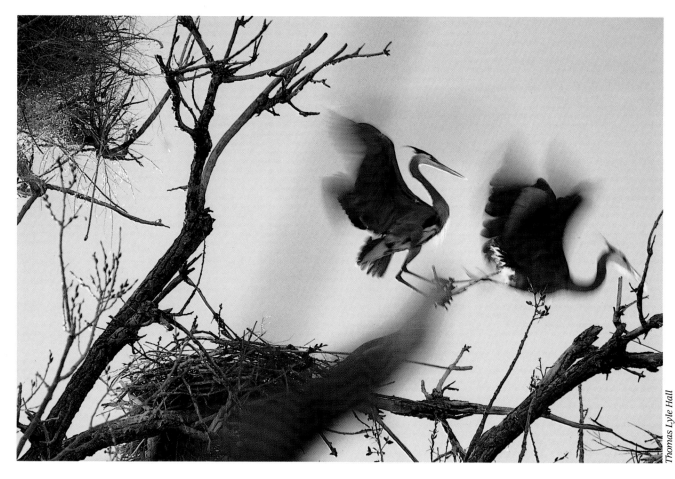

Thomas Lyle Hall

Looking like great winged reptiles rising from the pages of a prehistoric picture book, a pair of great blue herons struggle skyward into flight. As animated as animals are, action is a rare commodity in most wildlife photographs. The reason is simple: it's easier to photograph animals when they're sitting still. But passive poses make for passive pictures; action gives life to the photos.

Get up early or stay out late to capture the best action. During the day most wild animals and birds conserve energy by being comparatively docile. Early morning and twilight are the times when most animals prowl for food and defend their territories.

Capturing action doesn't necessarily mean entombing it with fast shutter speeds. Often you can show animation by using a slow shutter speed (as the photographer did here) and allowing your subject to blur slightly. In order to have shutter-speed flexibility, you can use a medium-speed film. The photographer used KODACHROME 64 Film for this picture. A little blur goes a long way though; too much and a picture becomes an unrecognizable abstract.

To relate motion in wildlife pictures and still keep your subject sharp, try panning. In panning, you press the shutter while you are moving the camera with the subject. Use a slow (1/60 or 1/30 second) shutter speed.

When you do want to freeze action, use a very fast shutter speed, at least 1/500 second or faster. Fast films, such as 1000-speed films, are perfect for stopping action even in relatively dim light.

PEOPLE

Of all the things that people photograph, the one that they photograph the most is—not surprisingly—other people. Indeed, the desire to take photographs of family and friends for the family album is probably the impetus that gives most of us our first serious involvement in photography. Pictures of people can be the most meaningful and enjoyable to view. Whether we know the people or not, pictures of them are interesting because we are instinctively curious about others.

There are a lot of motives for photographing people. In photographing family and friends, for example, our objectives are obvious—we're trying to preserve faces, mannerisms, and special events that time has a way of stealing from memory. But memories are only a fraction of the reasons why people photograph other people. Photographs of people can also be used to document political and social aspects of our society, to show unusual or interesting lifestyles, what someone does for a living, or they can just relate a fun or interesting slice-of-life.

Because we have a natural empathy for other human beings, pictures of people are also powerful instigators of emotional response. Shyness, humor, pensiveness, joy, exuberance, and sadness are all emotions that you can easily capture with your camera.

Perhaps the most important aspect of taking any portrait is choosing a style or technique. Basically there are three styles of portraiture that you have to choose from: formal, informal, and candid. Formal portraits are good if you want a straight, realistic likeness of friend or family member. By removing all extraneous surroundings and concentrating entirely on facial expression and body language, formal portraits can provide a penetrating insight into a person's personality. In the photograph of the teenage girl (page 77), the formal setting and direct camera-subject relationship have caused the subject to retreat into a reclusive, but very telling posture. Technically, formal portraits also give you almost total control over pose, lighting, and setting.

But formal portraits are unlikely to hold much interest for anyone other than your subject or their family. In contrast, more casual or informal pictures—whether planned or spontaneous—have a much more universal appeal and allow the subject to become more of a participant in the photographic process. The photograph of the cowboys (page 78) has an air of authenticity that exists because the subjects were shot in familiar surroundings with objects that are a part of their everyday lives, and they were allowed to choose their own poses.

Candid photography is probably the ultimate test of your people-photographing ability. In photographing people candidly, you not only have to capture an interesting pose or happening, but you have to do it without the knowledge or help of your subject—and you are always working at the mercy of existing lighting conditions. What's more, if your subject notices that he is being photographed, he'll often turn or move away; although sometimes the best pictures will occur just when the subjects detect they're being photographed.

Most importantly, whoever your subject is—whether it's a friend or stranger, whether you shoot in your own kitchen or in a city half way around the world—remember that each person you photograph is an individual. Even if your photographic encounter lasts only a brief second, take time to mentally acknowledge their individuality and it will show in your photographs.

Posed Portraits

Although not all of us enjoy being the target of a formal portrait, from a photographer's perspective, making a planned portrait can be a very creative and challenging opportunity. Without props or meaningful settings, the photographer has to find a way to draw out the personality of the subject and relate it to the viewer. In this young girl's penetrating but partially obscured stare, the photographer has eloquently portrayed the emerging conflict between bashful youngster and coy adolescent. The pose, clarified by a black sweater that contrasts with the flesh tones, teeters between graceful and gawky—again, appropriate for a teenager.

The two most important controls you have in making a formal portrait are the pose and the lighting. The pose is important particularly since most people do have certain angles that are more flattering than other angles, and different types of poses can create very different moods. Frontal views, for instance, can be interpreted as stiff and formal, but they have the benefit of direct subject-to-viewer eye contact. By contrast, profile views can have a detached, mysterious air about them, but they're not always particularly flattering. The three-quarter view, somewhere between full-face and profile, is usually the most pleasing.

The soft, even light of a north-facing window provides excellent portrait lighting—but it can be quite directional, making harsh shadowing

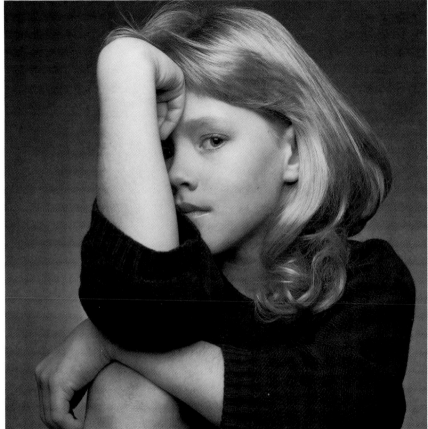

Michael Thornton

a potential problem. Use a white sheet or piece of art board to aim light into shadow areas. You can create another simple but more controllable lighting by bouncing an electronic flash into a reflective umbrella.

Photographer's comments: *"A friend asked me to take a picture of her daughter. I have tried many black-and-white films, but KODAK TRI-X is my favorite. I overexpose it a lot and then underdevelop it."* (Editor's note—By overexposing and underdeveloping the film, the photographer can obtain lower contrast, resulting in maximum shadow detail.)

Using Props

One way to provide insight into the character or personality of a portrait subject is to include props that are part of your subject's life. You can choose objects that relate either to your subject's hobby, occupation, or any other interests. Uniforms or clothing unique to one group of people can also be useful in projecting a certain image. By posing this pair of cowboys in their work outfits and with their working tools against a cattle shed, the photographer has encouraged them to be themselves and hence captured an attitude of self-confidence and mild aloofness that's characteristic of her subjects' rugged individualism. The photographer chose the soft, even lighting from the sky to display the cowboys and their gear.

Because the props that you use can imply much about your subject's lifestyle, it's important that you choose them carefully. Props needn't be exotic or cumbersome, but they should be symbolic: a welder wearing a tipped-up mask and holding a lighted torch; or an artist standing at an easel. Choose subdued backgrounds unless they include additional elements that elaborate the theme of the portrait—a pegboard laden with tools behind a cabinet maker, for example.

Giving your subjects a prop to hold helps answer the old question of what they should do with their hands. To elicit just the needed touch of animation and alertness, ask someone to

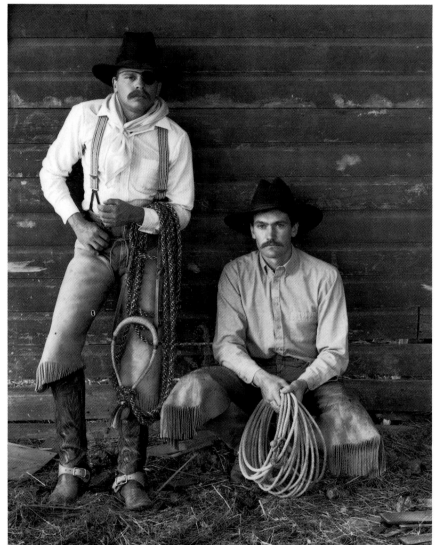

Bonnie Ballantyne

describe what a particular piece of equipment is used for or the history of an object. And when the need arises, don't be afraid to give direction —you're the only one that can see what's in the viewfinder. But be suggestive, not dictatorial; nothing robs spontaneity in a portrait like ordering the subject.

Photographer's comments: *"I wanted to make a picture of two friends with some of their gear. To obtain a good background for these cowboys and to light them evenly, I had them pose in the shade of a cattle shed. With my camera on a tripod, I had the men look into my camera lens while I was taking the picture. I used only available light."*

Babies

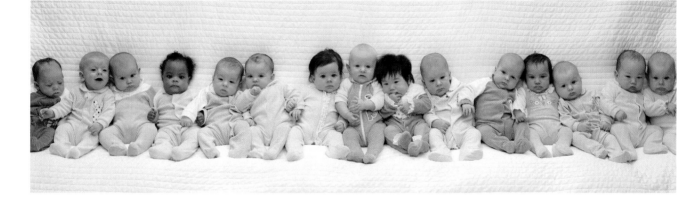

Sam Campanaro & Marty Czamanske

If you've ever endured the trial-by-patience of getting just one baby to pose for the camera, you can imagine the nightmarish, logistical possibilities of getting 15 babies in one picture—all upright (well almost all), alert, and facing the camera (more or less) at the same instant. But, that's just the magic that Kodak staff photographers Sam Campanaro and Marty Czamanske performed to create one of the most memorable group baby portraits of all time. Photographer Campanaro recalls how the photo was conceived and shot: *This picture was born quite by accident. My daughter showed me a picture she had taken with her KODAK Disc Camera. It was a picture of several of her friends' babies, from a childbirth class reun-*

ion, sitting in a row on the couch. I showed this picture to fellow photographer Marty Czamanske and suggested we might try a similar shot for the KODAK COLORAMA (an 18 x 60-foot transparent photo) in Grand Central Terminal in New York City. We decided to give it a try. We did all the styling, propping, and selection of babies ourselves, choosing 15 babies including my grandson and Marty's son. We more or less took over the studio for our whim; we had areas for changing diapers, feeding, and crying.

The actual shoot was much like a football game, with players moving in and out of the game. Parents were on hand, and as one baby would cry, wet, or fidget, the parent would scoop the child up and another parent would

scurry in with the replacement. At one point all the babies were behaving and we made several rapid exposures of this "time-out" in the action. Well, it turned out to be the most popular COLORAMA ever. The company receives lots of letters and requests for prints. I keep in touch with all 15 families and we hope to photograph the children at various stages as they grow up.

Of course, you may never have occasion to photograph such a large herd of youngsters at the same time, but the lessons are applicable to making any type of formal group portrait: A well-conceived plan, perseverance, and a kind nod from providence will usually get you a much better picture than you imagined possible.

Interpretive Portraits

The setting in which you photograph someone has a profound influence on a viewer's interpretation of who your subject is and what his or her life is like—even if, as in this case, the situation is a hoax created to fool the viewer. Rebellious and anti-social as they seem, the terrible threesome in this photo are actually just friends of the photographer dressed up to play the part of young toughs. It's a scene that works exceedingly well, because the photographer knew exactly how to match an adult's stereotyping of teenage rowdies.

More often, though, when choosing a location for an interpretive portrait, we choose one that reveals something of the true interests and lifestyle of the person you're photographing: a gardener amid flowers in a greenhouse or a commercial fisherman on a wharf tending to his nets. By showing the places where a person works, plays or lives, you offer the viewer a more intimate glimpse of who that person is and what his or her daily life is like. It's interesting, too, how someone who can look completely nondescript in a neutral setting suddenly exudes great individualism when photographed in a telling and authentic location.

With any environmental portrait, take particular care in choosing the viewpoint and framing. Too much extraneous information can rob attention from your subject; too little can make an ambiguous statement. Look for angles that clearly indicate the location's theme and then eliminate all but the most essential elements: You don't need to show his entire workshop to know that a man in overalls standing at an anvil is probably a blacksmith. A zoom lens is useful for experimenting with various compositions where you are limited by physical mobility.

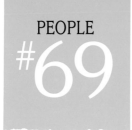
Emotional Portraits

As much as we'd like otherwise, not all the events in our family lives are happy ones. Nor necessarily do all the photographs we take of our families represent joyful memories. Some, such as this one, may capture quite painful moments. The photographer describes the scene: "My uncle was critically ill (he has since passed away). My aunt was caring for my uncle 24 hours a day; they truly represented the typical family devotion of Greek villagers. I simply snapped a picture of their reality. It was made in the village of Kallithea, Thebes, Greece."

To make a single photograph that sums up the many aspects of such an emotional situation so eloquently is no easy task. Photojournalists are trained and hardened by experience to see these events objectively and in purely photographic terms. But for most of us, making such an image—particularly of loved ones—would be difficult. Still, because such images help to relate the complete spectrum of human emotion that our families are built upon, capturing them has great importance.

Moreover, while the photograph is indeed one that may elicit sadness, it is an equally poignant portrayal of family dedication and personal dignity. In the years when the sorrow of the death has diminished, these are the qualities that the photograph will evoke; and for future generations of the family, it will remain a wonderfully authentic glimpse into their ethnic heritage.

Catherine Dritsas

Candid Portraits

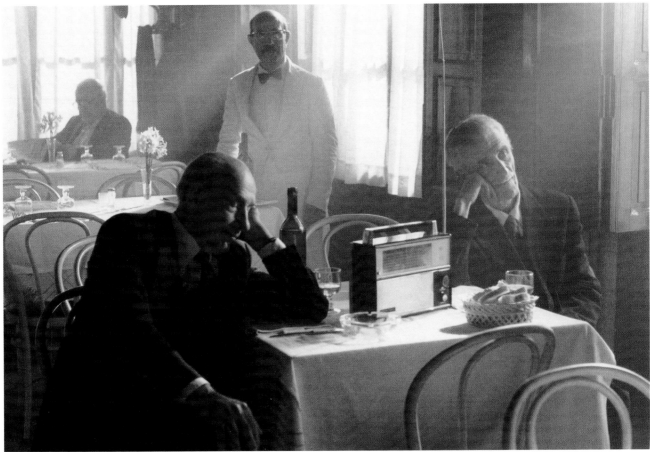

Gary A. White

Some of the most revealing—and often amusing—photographs of people are those made when the subjects are completely unaware they're being photographed. Unposed, uninhibited, and completely natural, candid photographs are fascinating because they show us people as they really are, not necessarily as they would like us to think they are.

To make candid pictures, you must learn to be as discreet as possible. As soon as someone notices they're being photographed, they'll probably change their demeanor and begin to act self-consciously, destroying the delicate

sense of spontaneity. Often you can take advantage of your subjects' preoccupation with their own activities to keep you from being noticed. Lulled into a dreamy mood by wine, radio, and afternoon sunlight, these two gentlemen in a European cafe were completely unaware they were being photographed. Only the waiter at the back of the room seems to have noticed the photographer's intent.

Being prepared is essential. Use a high-speed film, such as 400-speed film, so you can capture the atmosphere of existing light, which is so important to this photograph. Always preset your exposure and rough focus.

Then once you become aware that a potential photograph is imminent, you can just raise the camera to your eye and shoot. Also, perfect timing is crucial: raise the camera too soon and you'll tip your hand; too late and you may miss the picture. Automatic-exposure autofocus cameras are ideal for candid work since they free you from technical chores and let you concentrate on capturing the decisive moments. But beware of loud auto-winders and built-in flashes that may draw attention to you.

Social Commentary

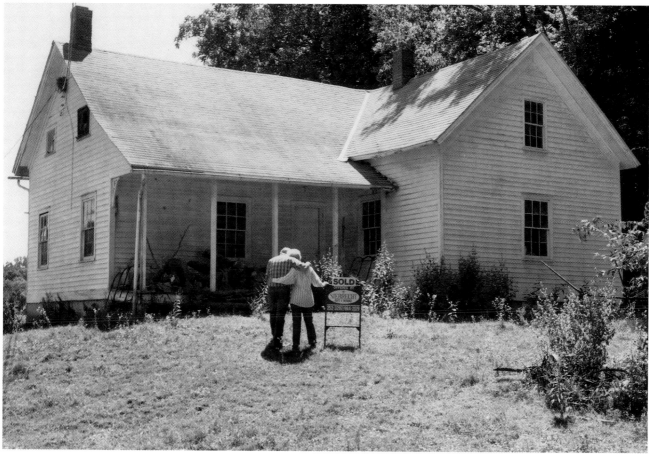

Scott Stade

Although most of the photographs of people that you take are probably intended as personal remembrances of family and friends, or as artistic interpretations of characters that you know or encounter, there's nothing wrong with broadening your horizons and trying to capture more profound concepts. Social commentary, for example, is an area that has a long history in serious photography—and it is not an area owned exclusively by professional photojournalists or documentary photographers. When you think about it, the family album is basically a journal of the social changes within one very tightly-knitted social group: the family.

Families aside, almost any topic of social interest can be the subject of an interesting photograph or series of photographs. You can pick an issue of local concern—kids hanging out on city street corners—or of broader scope, like people protesting abuse of the environment. In the photograph here, the photographer has tried to show the desperation of hard times in his native rural community by posing a couple in front of a recently sold farm. Of course, not all social commentary has to be so serious in concept— you might want to photograph something as frivolous and innocent as the changing fashion fads of teenagers or the latest in wild hair styles.

The key element in any socially relevant photograph is the attitude of you the photographer; whether your attitude is one of detachment, sympathy, irony, or satire—it will show in the final photographs. Indeed, most socially probing photographs are as much a reflection of the photographer who made them as of the subjects.

Photographer's comments: *"I wanted to depict [the] sadness or emotion of rural economic times, and I planned the picture ahead of time."*

Self-Portraits

The one person that most photographers probably photograph least is themselves. Yet taking pictures of yourself can be a challenging and enlightening experience. Taking self-portraits also has several practical advantages: you'll always have a willing (and hopefully patient) subject at the ready and, if the results aren't exactly what you had anticipated, only you will know. You can also use yourself as a test subject for experimenting with unusual lighting or other creative techniques. The ghostly, low-angle lighting used in this self-portrait, for instance, is something that another person might not find particularly flattering—but it certainly creates a dramatic effect.

Technically there are a few different ways to photograph yourself. One is to choose a composition that looks interesting and then, with your camera on a tripod, use the self-timer to fire the camera after you scramble into position. Since the timer will allow you only about 10 seconds to position yourself, it helps if you figure your position ahead of time and mark it with tape or a chalk mark. It also helps in visualizing the image if you have a friend act as a stand-in while you set up the photo. A simpler self-portrait technique is to just photograph your reflection in a mirror or other shiny object. You can use the camera as a prop and allow it into the composition (holding it away from your face), or use a tripod and frame the scene to exclude the camera's reflection.

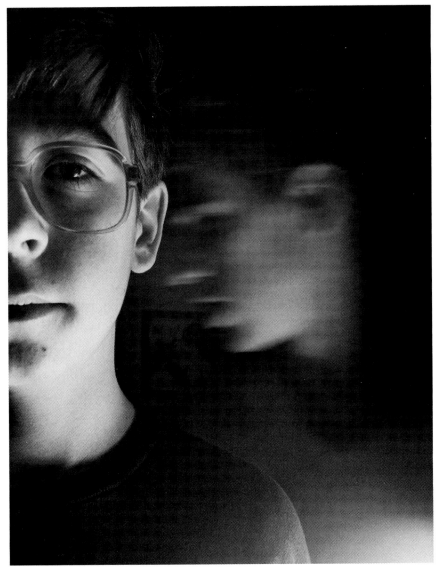

Kevin Fox

For an even more interpretative portrait, consider photographing your reflection in a store window or your shadow on the sidewalk—or just aim the camera down your body from eye level. You can even include other people, as the photographer did here by showing his brother in the background.

PEOPLE
#73

People at Work

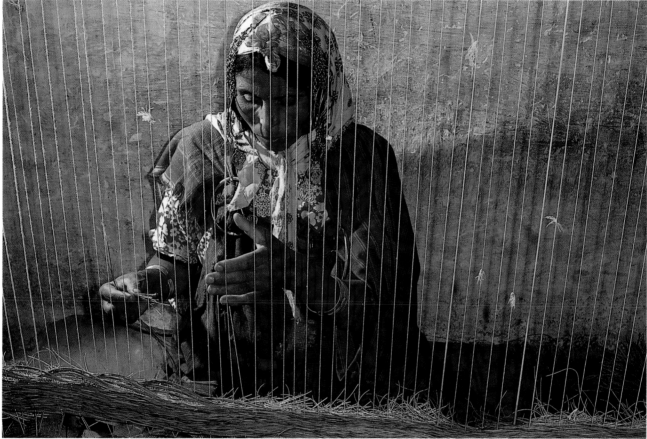

Sebastien Marmounier

Photographs of people at work can be quite interesting because they often show us an aspect of people's lives that we wouldn't otherwise be exposed to—and very often their work environment or occupations are, themselves, visually interesting. When you stop to think of all the different occupations there are in the world—from tuba players to lion tamers, librarians to candlestick makers—it gives you a pretty big list of subjects and ideas to choose from. And since most people are flattered that someone is interested in their work, finding cooperative models—even among strangers—is usually easy.

The kind of work a person does or the work location will largely determine the type of portrait you make. If your subject works in a visually exciting environment—an air-traffic controller surrounded by a colorful, high-tech console, for instance—take advantage of it by using a wide-angle lens to reveal the color and drama of the setting. If your subject is doing some sort of close handiwork—such as a potter throwing a vase—use a medium telephoto or move in to frame the artist and wheel closely. By tightly cropping this portrait of an Indian woman weaving, the photographer has focused our attention immediately on her concentrated expression and careful hand positions. Very often too, a tool or piece of equipment can be exploited as a powerful compositional device; here the woman's primitive loom not only reveals her occupation, but offers the photograph a strong element of design.

People and Their Pets

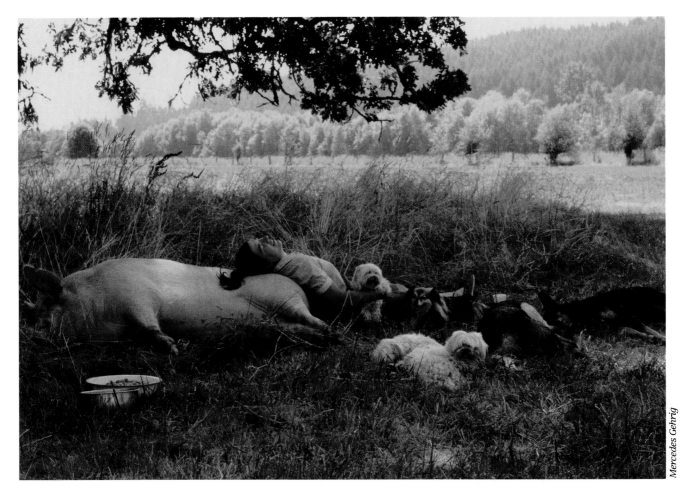

Mercedes Gehrig

Next to the relationships we share with other people, the friendships we enjoy with our pets probably represent the strongest emotional ties we have in our daily lives. So it's only natural that sooner or later you'll want to photograph a friend or family member and the family pet(s) together. Very often too, the kind of pets people have and the way they interact with them reveal a great deal about their personality and lifestyle. If your subject's pets happen to include six dogs and a hog, for example, it's a pretty sure bet that animals are a big part of her life.

Deciding on a situation or a location for the portrait will depend

mostly on what kind of animal it is, the particular human/animal relationship, and the mood you're after. By photographing this girl and her eclectic menagerie in such a relaxed pose and tranquil environment, for example, the photographer has vividly evoked the idyllic, pastoral existence of the group. Conversely, you might want to photograph a dog

breeder and his champion Irish setter in a more formal pose that reveals the owner's pride and shows the dog's features to best advantage. Most importantly, whatever the pet and wherever the setting, try to instigate a telling interaction between pet and owner—a young girl cuddling a new kitten or a teenage boy rough-housing with his dog.

Photographer's comments: *"It is so difficult to get so many animals to stay still all at once. I kept taking shots (and used up two rolls of film), until they were bored with the project."*

Silhouettes

Informal pictures that show parents and children enjoying each other's company can make great additions to the family album. But very often attempts at taking such pictures result only in stilted poses that reveal little about the true intimacy or character of that relationship. One good way to make pictures seem more impromptu and fun is to photograph your subjects involved in some mild but symbolic activity.

The kinds of situations you can look for will depend mostly on the age of the child. With infants, for example, it might mean something as simple as a father helping the baby eat with a spoon for the first time. As toddlers, kid's personalities really begin to develop and the physical interaction of the relationship becomes much more obvious. In the exuberant shot here, the photographer has made it apparent that the mother and child share a very playful and trusting relationship. Also, by photographing the pair in silhouette, we are given an image that is at once both personal and universal.

Public displays of physical affection between most parents and kids begin dwindling as kids get older and usually becomes all but invisible by teenhood. But the bonds remain and, though more disguised, can still be captured on film—a father and teenage son or daughter splashing each other as they wash the car, for example.

To make a silhouette, take your light reading from the bright area and shoot at that exposure. If you want some detail in the foreground, however, shoot about 15 minutes after sunset when there is still a little daylight around and balance your exposure readings midway between the foreground and the sky.

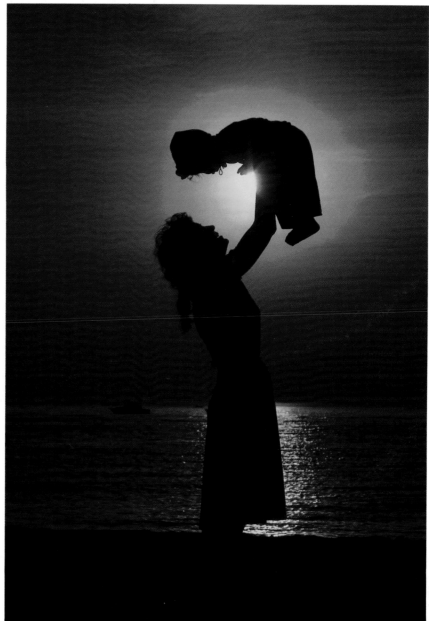

Randy Wegener

Character Studies

All of us enjoy getting to know interesting characters, but very often the encounters are all too brief. One way to sustain the memory and share our appreciation of an individual is to make a portrait that elicits something of his or her personality. Fortunately, good character subjects—like this handsome Taos Indian elder—often have distinctive physical appearances that match the strength of their personalities. The combination can make for some wonderful photographic studies.

In planning a character study, strive to find a blend of both composition and technique that accents one or more of your subject's more outstanding physical characteristics—probably the very characteristics that attracted your attention in the first place. By moving in tight and using a slow-speed, fine-grain film to make this insightful portrait, Kodak staff photographer Neil Montanus has shown us a subject whose facial lines and furrows etch the unmistakable map of age and a rich life. My intent was to show the texture of the skin and to show how the extreme sharpness of the film would render the fine detail, he said. The photographer used 25-speed film.

Expression is important too. Coarse and time-worn as the Indian's face is rendered, it is a portrait of inviting sincerity and warmth. You'll rarely get the expression you want without coaching, so don't shy away from directing where your subject should look—into the lens, at the horizon, etc. Unless you're concentrating strictly on facial expression, pay close attention to body language and props. The careful positioning of the hand gives this portrait a timeless and thoughtful mood, while the adornments of native jewelry and carefully wrapped braids add authenticity to the study.

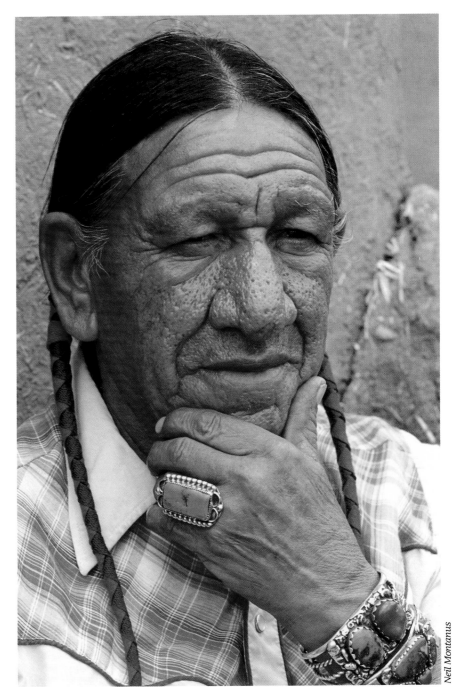

Neil Montanus

Foreign Portraits

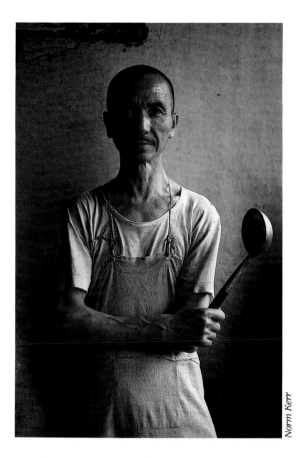

Norm Kerr

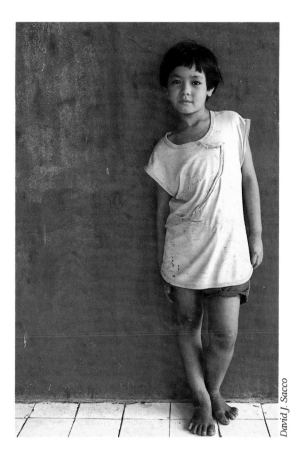

David J. Sacco

Travel presents some excellent opportunities to photograph people. Nothing conveys the character of a foreign land or recaptures travel memories quite as honestly as portraits of the people who live in the places we visit. Informal street portraits, in particular, are wonderful at capturing the flavor and lifestyle of a region in an honest and appealing way. Strangely, many of us who would never think to casually photograph a stranger on the streets of our own hometown are quite comfortable photographing people in foreign lands.

Children are probably the easiest potential street subjects, since their lack of inhibition is an international quality. The shy smile and only mildly self-conscious pose of the young boy

(above) photographed in Mandalay, Burma, gives the photograph a tremendously engaging and casual quality. The simplicity of the setting further reinforces the natural unaffected pose.

While children are best photographed candidly (or at least very informally), you'll find most adults are quite cooperative at posing if you ask their permission to photograph them. Language is rarely a barrier that a few simple hand gestures can't overcome. Photographer Norm Kerr describes how he was able to get the Chinese cook (opposite) to pose: *I indicated in pantomime how I'd like him to hold the soup ladle, and he seemed to understand my intentions, and posed*

as the professional he was—the master of the kitchen. His dignity and strength impressed me.

Be sure to approach strangers in a friendly manner when asking them to pose, and do not force your picture taking upon them. Some people shy away from cameras, particularly people from certain countries. It's always a good idea to ask for permission before photographing anyone.

In the long run, interacting with your subjects—children or adults— may be more rewarding, not only because you can feel more at ease about photographing them, but because you can briefly get to know your subjects as people instead of seeing them as mere photographic curiosities.

T E C H N I Q U E S

Techniques are the *hows* of photography; they describe the methods that photographers use to make photographs. Some techniques—like exposure and focus—are the basics of good picture taking. Mastering them lays the technical groundwork for all of your photographic endeavors. To a large degree, the current breed of auto-everything camera has made acquiring these basic skills less significant: Press a button, get a picture. Left to its own devices, however, even the most sophisticated camera knows only one way to take a picture—the "correct" way. Technically correct. Good exposure, sharp focus.

But letting a camera decide what constitutes the right or wrong way to take a picture is kind of like letting a neighbor do your grocery shopping. You'll be eating by someone else's tastes. Beyond the clinical perfection of "correct" technique exists a frontier of imaginative applications and creative techniques that will allow you to stir and season your photographs to your own discriminating palate.

Many creative camera techniques are simply novel uses and adaptations of basic camera controls. For example, while many 35 mm SLR cameras have shutter speeds capable of stopping a pole vaulter in mid-air, some photographers prefer to interpret motion through slow shutter speeds.

They allow the action to blur so it becomes part of the technique. Similarly, photographs such as the star trails on page 104 are made by ignoring the shutter speed dial entirely and using exposure times counted in minutes or hours instead of fractions of a second.

Still other creative techniques are the byproducts of technological innovation. Zooming (page 109), for example, is a technique that did not become popular until the invention of the zoom lens. While lens manufacturers probably never envisioned nor planned this particular aberrant use, the technique still has become popular. Special-effects filters (page 111), on the other hand, are examples of where technology has been intentionally developed to serve the needs of creativity-hungry photographers.

If in-camera techniques don't offer you enough adventurous possibilities, there is also an army of post-camera techniques that allow you to continue manipulating the image long after the original exposure. Some, like posterization (page 94), require darkroom experience; others like hand coloring (page 106) demand nothing more than a felt-tip pen and a little ingenuity.

Finally, there is the one aspect of creative technique that even technology has yet to better: imagination. Greater than a fistful of fancy filters or a camera bag crammed with expensive zoom lenses, and more clever than the slickest, electronic wonder cameras, imagination is the secret genie behind so many great photographs.

Without imagination your camera is a lame chunk of metal and glass, lapping up and spitting out redundant images of the physical world. With imagination, a simple box camera becomes an Aladdin's Lamp, conjuring brave new visions from fertile musings.

How can you rub this magic lamp of imagination? One way is to look at photo books—like this one—and see what other photographers are doing. If a particular technique or idea intrigues you, try it. Often intentional mimicry breaks a log jam and creates a flood of unexpected discoveries. Another way to stir your creative juices is to explore *What if?* possibilities. What if you held a piece of purple cellophane in front of the lens? What if you made a time exposure while swirling on a rope swing? What if…?

Storytelling Viewpoints

Sebastien Mamounier

Somewhere between spotting a potential photograph and pressing the shutter button you have to decide exactly the position from which to make the photograph. Above the subject? Below it? To the left or right? In this case, without the high vantage point the photographer would have not captured fully the essence of the scene.

Much has been written in photographic texts about the virtues of choosing the correct viewpoint. High viewpoints organize. Low viewpoints add drama. The correct, lateral viewpoint helps reveal the true form of a subject and its relationship to its surroundings. But perhaps the greatest reason for exploring different vantage points is variety. Most of us become so accustomed to the world as we see it at eye level that we're surprised and delighted by variation.

The more radical the viewpoint you choose, the greater the surprise. Was your initial response to the scene above because of its content or the excitement of its aerial perspective? Although such extreme alternatives

aren't always available (and can sometimes be a distraction rather than a help), vertical or lateral shifts of just a few feet can have a major effect on the interpretation of a scene.

If you doubt the power of viewpoint, try photographing something familiar from a variety of different angles. How different does your car look when viewed from the street than from the front steps or the bedroom window? How do the relationships between subject, background, and lighting change?

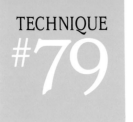

Details

Neal Rhodes

Mention the term "close-up" photography to most photographers and they immediately think of flowers and insects and tidbits of the natural world that are the subjects commonly associated with close-ups. But the same macro lenses and close-up attachments that you use to photograph a beetle creeping through the morning dew you can also use to explore the myriad tiny details of everyday objects and environments, from the intricate weave of a drapery fabric to paint drips on a drop cloth—or, in this case, the pattern of beaded raindrops.

Looking for tiny details with a camera and close-up lens is kind of like being a kid again and spying on the world through a magnifying glass. By closing in on an isolated detail of a familiar object or scene, you can reveal wondrous tales of hidden intrigue, so near and yet so very unnoticed. Objects bland in their familiarity become alluring in their abstract beauty. For tiny details like these droplets, you'll need a lens capable of working at about 1:2 (half life size); but even with a normal lens you can

often isolate interesting segments of larger objects—the peeling layers of an aging barn, for example.

In searching for photogenic details, look particularly for subjects that stress attractive patterns or unusual textures. In this photo, the rows upon rows of shiny droplets captivate the eye with their seemingly manufactured symmetry. But as with any pattern, repetition can become boring; the somewhat brash swipe that smears the pattern is just the visual twist necessary to keep the eye on the edge of curiosity.

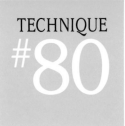

TECHNIQUE #80

Rainbows

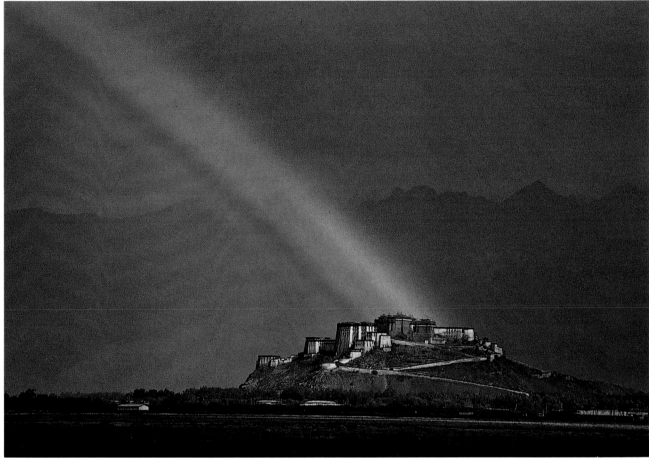

Galen Rowell/Mountain Light

Galen Rowell is a photographer and mountaineer whose photographs of the world's great mountains, taken from a climber's perspective, have won him fame and success. He is also a photographer (like many less famous photographers) who is very fond of photographing rainbows, and this photo titled "Rainbow Over Potala Palace, Lhasa, Tibet" taken in 1981 is perhaps his most famous rainbow photograph. It has been reproduced in magazines, advertisements, travel publications, and as a fine art print. It is, in fact, probably the most published photograph of a rainbow ever made.

Fame and fortune aside, however, the wonderful thing about rainbows is

that anyone can photograph them. And they're just as exciting whether you photograph them over a palace in a distant land, or over a house in your own neighborhood. A rainbow hanging in an empty sky won't be as exciting as one with an interesting foreground. Since most rainbows linger briefly, it's best to start scouting a good location during a rainstorm. Usually though, rainbows take you by surprise and you just have to make the most of the foreground that's in front of you.

Exposure is the key to good color in a rainbow photograph. With color negative films, you can shoot at the exposure that's correct for the surrounding sky area. With slide films,

the colors of the rainbow will be more saturated if you underexpose from the sky reading by 1/2 to 1 full stop. If the foreground is brightly lit, you will probably want to expose correctly for that. Usually this will cause the sky to appear darker and can offset a rainbow nicely.

Also, since rainbows are made up of reflections of light on minute droplets of water, you can intensify their brightness even more with a polarizing filter. You can see the colors of the rainbow get stronger and weaker as you rotate the filter. But be careful of the filter's position, because in the wrong position it can also wipe out the rainbow.

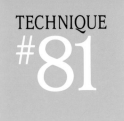

Posterization

For photographers who have their own darkrooms, pressing the shutter button isn't the end of the photographic journey—it's only the beginning. Beyond the original negative or transparency lie countless paths of creative derivations waiting to be explored. The image here, for example, was created using an inventive—and somewhat elaborate—darkroom technique called *posterization.*

Posterizations are created a using a series of high-contrast, black-and-white negatives as intermediate steps between your original negative or slide and the final print. Rather than record a continuous record of tonal values, high-contrast negatives divide everything into either highlights or shadows, depending on the amount of exposure given. In other words, the photographer can manipulate which areas of a scene will print white and which will print black. These intermediate (separation) negatives are printed in register and in various combinations to create an image of multiple, but disjointed, tonal values.

Photographer David S. Lewis describes the process he used: "I had helped my father with some posterizations and I thought this picture was perfect for such a technique. Using my enlarger, I made 4 x 5-inch separation exposures from the original slide on KODALITH Ortho 2556 Film. This produced high-contrast negatives for the shadows, midtones, midhighlights, and highlights. These negatives were then contact printed onto more 4 x 5 KODALITH Film to create positives. These positives and negative were then combined as pairs, placed in the enlarger in succession, and printed."

A lot of work to create one photograph? Perhaps, but then one-of-a-kind pictures sometimes *are* a little difficult to come by.

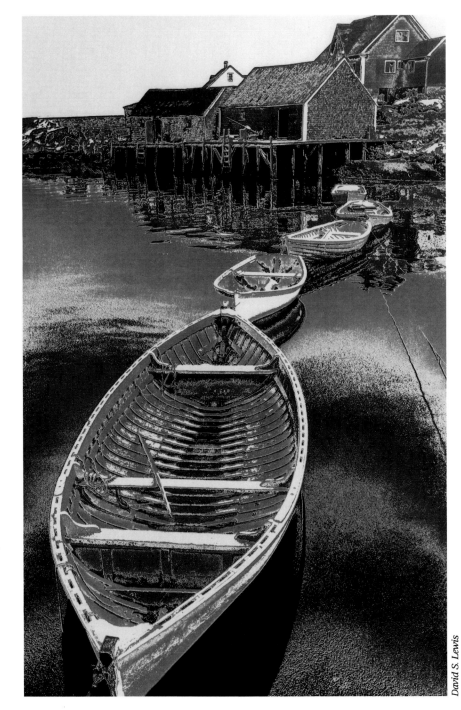

David S. Lewis

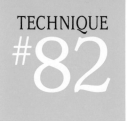
Timing

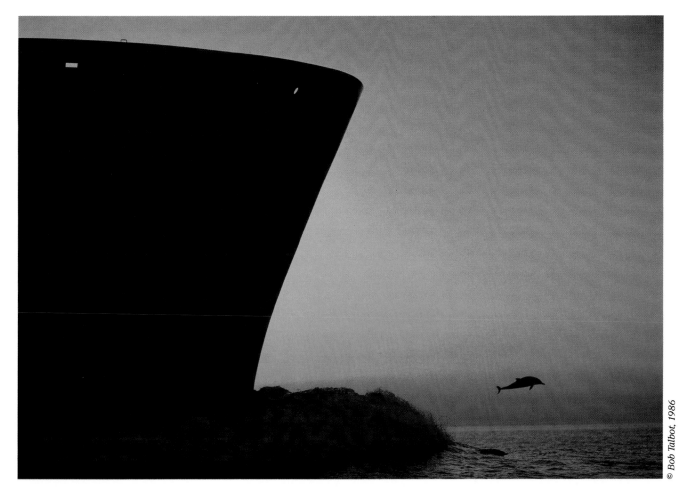

© Bob Talbot, 1986

Many wonderful photographs are the result of the photographer having an impeccable sense of timing—knowing precisely when to press the shutter to capture the peak of activity. Whether you're photographing a race horse at the finish line, a dog yawning, or a porpoise in mid-air, there is an all-too-brief instant when all of a scene's elements reach a climactic juncture. Missing this instant often means missing the picture entirely.

The keys to mastering a sense of timing are lightning reflexes and good anticipation. You can practice both—even without a camera—simply by watching the world around you. Watch as a businessman leaps to hail a cab or the papergirl tosses the evening newspaper from her bicycle. As the action peaks, press an imaginary shutter in your mind's eye and see if your timing is appropriate.

Of course, all the good timing in the world won't mean a thing if your camera isn't ready. Whenever action is likely, make sure your camera settings—exposure and focus—are preset, and have the scene framed so that all you have to worry about is deciding when to press the shutter button. And always press it a split-second before the action occurs so that the shutter has time to trip.

Exaggerated Grain

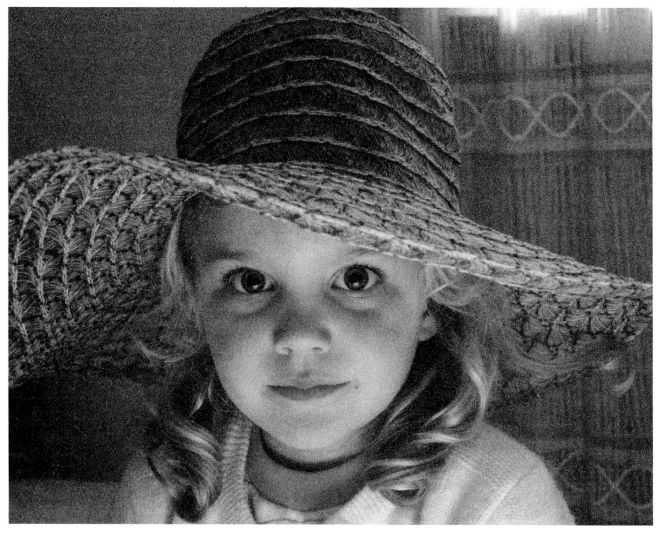

<div style="text-align: right">David Hess</div>

If you've ever taken a picture on a fast film and then had it blown up very large, you know what grain is—it's the mottled sand-like texture across your pictures. Usually, photographers try to avoid excessive graininess. But as with most aspects of a creative media, some inventive thinkers have found a way to put excess grain to work artistically. Instead of obeying the ground rules used to prevent grain from becoming too apparent, you can exaggerate grain until it looks like a built-in mezzotint screen.

With color films, two things control grain pattern: film speed and degree of enlargement. The faster the film and the higher the degree of enlargement, the more obvious the grain will be. Even though the photographer of this picture used a flash to make this portrait, he also used a very high-speed film—1000—and enlarged it greatly to give the picture its grainy impressionistic quality.

If you wonder how one of your existing images would look with a grain effect, there are a few tricks you can use to create grain. One way is to copy the print onto very high-speed film and then have an enlargement (8x10-inch or larger) made from it. A better way is to pick an interesting detail from the print and then use a macro lens to copy that small area of the print and have it blown up to a larger size. Or you can have your processing lab make an oversized enlargement from a very small segment of the negative or slide area.

TECHNIQUE #84

The Mundane

George R. Janecek

No frustration is quite so great as having the creative energy to take pictures and not being able to find anything "worthwhile" to photograph. It's easy to get inspired by a colorful sunset or a glimmering city at twilight. It's not so easy to find inspiration in the mundane objects of our daily haunts and habitats. But the fact is that interesting subjects abound and almost anything can make a remarkable photograph—even a subject so ordinary as a row of toothbrushes over the bathroom sink. The key is awareness: learning to look for and recognize the beauty of the commonplace.

How to develop this precious gift of visual alertness? The first and probably most crucial hurdle to overcome is learning to see objects beyond their normal utilitarian value. Toothbrushes have their obvious functional purpose, but they also have shape and color and form and texture. Divorce yourself from functionality and see familiar objects on a purely visual basis. Then, too, you must be sensitive to the subtle dramas and myriad guises of light. It was partly the unexpected aura of morning sidelight that roused the photographer's creative ambitions enough to photograph this scene.

Once you've developed an awareness to the potential of the mundane, you'll find, as this photographer did, that inspiration can strike at any time and in any place. *I was sitting in my bathtub contemplating my lot in life when my eyes happened upon the haphazard composition of toothbrushes illuminated by a dramatic light...I got out of the bath, grabbed my camera and made the picture.* Not all of us will develop such a high degree of awareness, but learning to see the ordinary as exceptional is the basis of learning to see as a photographer.

Mood Through Weather

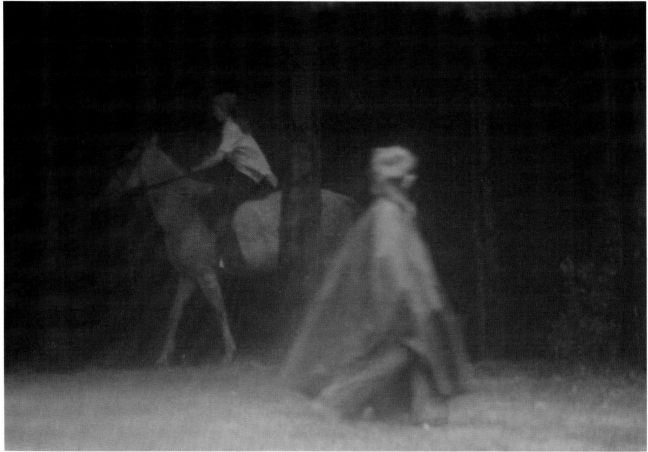

John P. Vaeth

Gray and rainy days may seem like better weather for sitting inside and getting cozy with a good book than tramping off with your camera, but the moody feeling such days can add to otherwise ordinary scenes makes enduring a little wetness more than worthwhile. In color pictures particularly, the muted shades and harmonious hues of a dreary day can imbue your pictures with a quiet, impressionistic quality. In this scene of the woman wearing a cape, the photographer captured a mysterious, dreamlike quality in the scene.

Gray skies themselves usually don't add much to a picture (unless you're trying to show the isolation of a light house, or something similar), so it's best to find scenes where you can crop the sky away. Besides, if you set your exposure for a dark foreground area, the sky will probably wash out into a pale uninteresting white. As with fog, gray skies and rain can mislead meters. A gray sky may fool your meter into thinking the day is darker than it really is; rain or heavy mist, on the other hand, reflects a lot of light and may provide the wrong-exposure information. For more consistent results, take light readings from a gray card. You can also take a reading from the palm of your hand and then open up one stop from the recommended setting.

As you take pictures in the rain, bear in mind that your camera won't hold up to a soaking as well as you— keep it dry! Your car makes a great cover for rainy-day shooting around town; in the city look for protection under awnings or in doorways. You might also consider one of the new "all-weather" cameras that don't need any special protection in rain or snow.

Photographer's comments: *"What I like about this picture is it's mystery… the unexplained activity in what seems like a mythical forest. To achieve the soft undetailed effect, I shot the picture through a rain-smeared windshield."*

Wide-Angle Distortions

Vern Fisher

Unlike telephoto lenses that swallow up space and scrunch distant objects close together, wide-angle lenses have an opposite effect: they exaggerate size and distance. Wide-angle lenses expand the spaces between near and far, and make objects close to the lens seem much larger than distant ones. In some situations, such as scenic photography, you can use these inherent qualities to enhance the depth or three-dimensionality of a scene. On a more experimental level, you can exploit wide-angles to conjure up some very unexpected (not to mention peculiar) distortions of perspective. By placing close objects along the frame edges, you can warp them into dramatic curves.

Perspective distortion with wide-angle lenses is most blatant when you place the subject, or part of the subject, close to the lens. By moving to within a few inches of this woman lying in a tanning booth, for example, the photographer has produced an image of distorted proportions and falsified perspective that captures perfectly the abstract mood of the high-tech setting. The woman's hair and head seem to be bursting out of a long futuristic cocoon, while her body is made all but invisible by her protruding shoulders.

The best focal lengths for wide-angle exaggerations are in the 16 to 24 mm range. Lenses shorter than 16 mm fall into the category of "fish-eye" lenses and, though their distortions can be even more bizarre, the lenses have little use in everyday photographic situations. On the other hand, because lenses longer than 24 mm are closer to normal in focal length, their effect on perspective is more moderate.

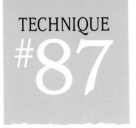
Panning

Panning is a favorite technique among sports and action photographers because, like the blurring technique described on page 110, it's an effective way of expressing the sensation of motion and speed in a still photograph. Whether you're shooting a race car roaring down the track or skateboarders rallying in a parking lot, panning captures vividly the dynamic feeling of motion. With panning, however, it's the background that gets blurred, while the subject—in this case, the bicyclist—stays in relatively sharp focus.

To pan, track a subject as it moves across your path and shoot at a relatively long shutter speed. You probably won't get much of an effect at shutter speeds above 1/60 second, and at speeds longer than 1/8 second you run a higher risk of seriously blurring the subject, an effect that may occasionally be desirable but is more unpredictable. One rough rule-of-thumb is to use a shutter speed that's the reciprocal of the subject's speed: 1/15 second for a horse trotting at 15 mph, for instance.

Since focusing on a moving subject can be difficult, it's best to prefocus on a predetermined area and begin shooting the subject when it reaches that spot. To keep the camera (and the picture) flowing smoothly, begin your pan before the subject comes into the frame and follow through after the shutter is fired. And remember, with an SLR camera, once you fire the shutter the mirror will block your view of the subject, so it will take some practice to keep your subjects accurately framed.

Although panning works best when the subject is traveling horizontally across your path (because this is the direction of motion that blurs most

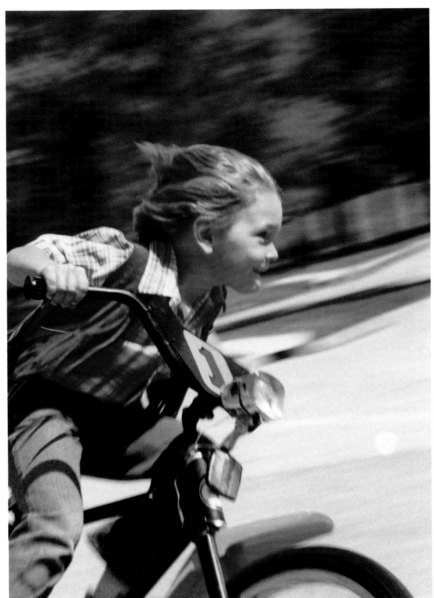

Ronald E. Kovach

easily in a photograph), this doesn't mean you have to limit yourself to framing the scene horizontally. In the energy-charged scene here, the photographer has exaggerated the exhilaration of the moment by holding the camera in a vertical position and framing the boy diagonally within the frame. As the photo also shows, pan-

ning works best when the subject occupies a large area of the composition.

Use a low- or medium-speed film (25 or 100) so you can use slower shutter speeds in bright sunlight.

Selective Focusing

Jeff Huerd

In most photographs, the goal is to keep as much of the subject area in sharp focus as possible. Pictures that are sharp from front to back seem natural, because that's the way we perceive scenes. But, as this example shows, restricting the zone of sharp focus to a selected area can produce unexpectedly dramatic results. By intentionally limiting focus to just the rim of the shotgun barrels, the photographer has created an image that hits us right between the eyes with its immediacy. The contrast between the sharp edge of the gun barrels and the mysteriously blurred background figure further heightens the ominous mood of the image.

The primary control in limiting the zone of sharp focus is aperture size—

the larger the aperture, the shallower the depth of field. To get results as dramatic as this one, use the maximum aperture available (usually f/1.8 or f/2.8), since a smaller aperture will begin to increase the depth of field. Use a low-speed film, such as a 25-speed film, to more easily obtain maximum aperture. Also get fairly close to the subject since depth of field also increases as you move further from the subject. If you are using anything other than the maximum aperture, always use your depth of field preview button to check the image before shooting. Remember: a picture that contains elements only partially out-of-focus will look more like a mistake than a special effect.

Although theoretically you should be able to limit depth of field with lenses of any focal length (except perhaps very wide-angle lenses), selective focus is most easily obtained with lenses that are longer than normal. Lenses in the medium telephoto range (70 mm to 135 mm, or zooms in that range) are ideal, since their depth of field is inherently shallow even when stopped down one or two stops. But whatever focal-length lens you use, choose the point of sharp focus with great care; the shallower the depth of field you're working with, the more attention the sharp areas will get. Maintain distance between the object in focus and other objects to emphasize focus fall off.

Shooting Through A Surface

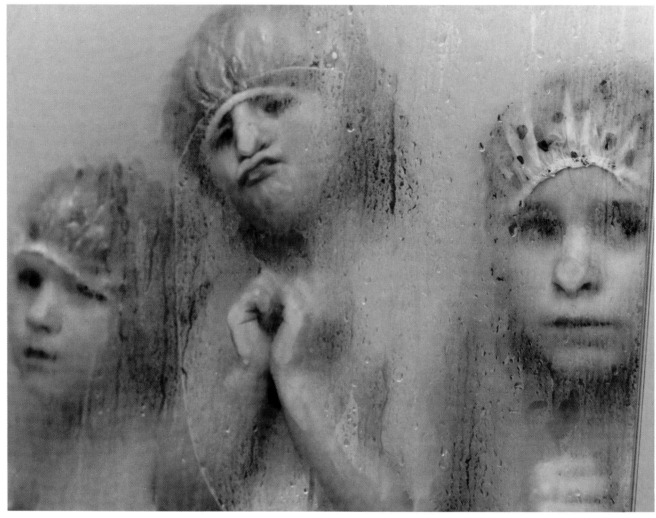

Patti Trautwein

Shooting pictures through existing transparent surfaces like glass, water, and plastic is an easy way to produce some unusual visual effects.

Glass is by far the most common and diverse surface you can exploit. Every day we peer through endless varieties of textured, frosted, and tinted windows. Still-life photographers sometimes shoot their arrangements through pebbled glass for an impressionistic effect. Even an ordinary window can be transformed into a useful creative filter by steam (as in the shot here), frost, fog, or just grime. For a slightly different approach, you might consider shooting a street scene or the faces of window-shoppers from inside a shop window, using the painted lettering and window display as part of your composition. In this photo, the transparent shower door was used to further advantage when the children pressed their noses against it for a humorous effect.

Water is another existing surface that can sometimes create exciting effects. A swimmer gliding just beneath the surface of a pool can take on a graceful abstract quality, as might colorful corals or fish shot in the shallows of a tropical beach. Plastic surfaces (like clear or tinted Plexiglas) are sometimes useful, but their poor optical quality tends to obscure the image rather than just distort it.

The biggest technical gremlin you'll encounter in shooting through any surface is, not surprisingly, reflection from the surface itself. If you're shooting from the indoors out, you can prevent most unwanted reflections by turning off any room lights that are reflected. Outdoors—shooting a display in an antique-shop window, for instance—you can use a polarizing filter to eliminate most reflections.

Still Lifes

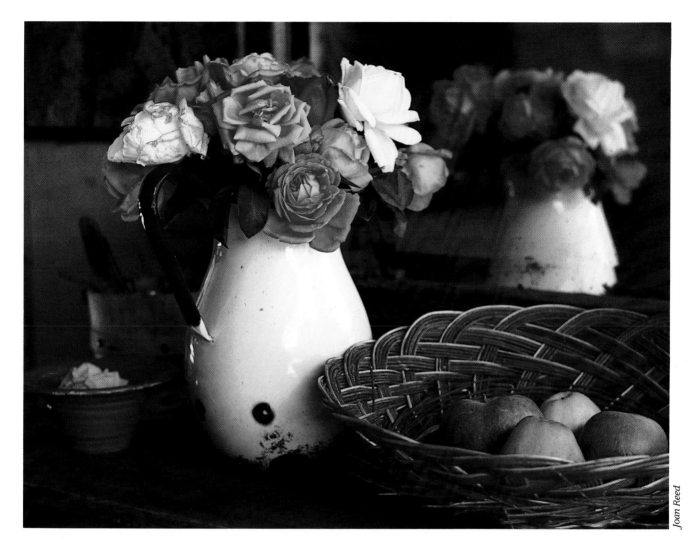

Joan Reed

Photographers, like painters, have long been fascinated by the compositional and aesthetic possibilities of the still life. With just a few common objects and a very simple setting, you can create some very pretty and interesting compositions. Photographing still-life scenes are also a way to polish your photographic skills. Unlike most photographic situations where you're at the mercy of existing conditions or the whims of your subject, still life photography puts you in complete command. Subject, setting, lighting—all are yours to endlessly arrange.

Still-life scenes can be any collection of visually interesting objects. Sometimes the photographer conceives the still life and then obtains the props and arranges them. Other times the photographer happens upon an existing still-life composition—as was the case for this photo. While visiting a local orchard, the photographer stumbled upon this charming arrangement of flowers and fruit on an old chest-of-drawers and photographed them just as they were found. By being alert to her surroundings, the photographer captured an

attractive vignette of country life that might easily have been overlooked.

Lighting for still-life photos can be artificial light or daylight. The diffuse light of an open window or skylight is ideal and has long been the light of preference for most still-life painters. The scene above was photographed in the light of an open door. For artificial lighting, one or two inexpensive photoflood lights are better than flash because you can see the effects of the lights as you change their position. Remember to match the film type to the light source for accurate color results.

Star Trails

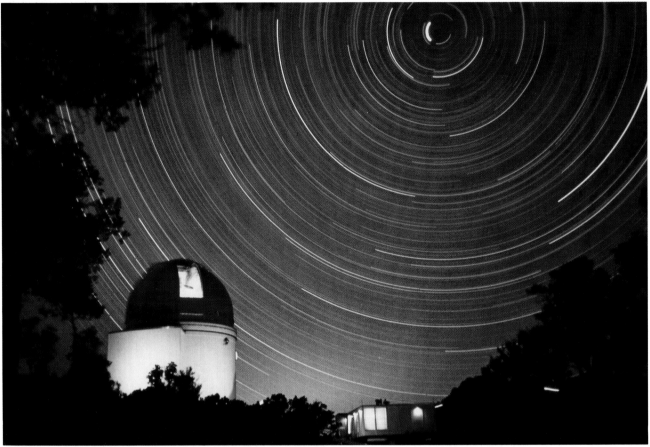

Richard H. Cromwell

Photographing star trails is probably the only occasion when the rotation of the Earth becomes the key tool in your photographic technique. By placing your camera on a tripod with the shutter locked open (using a locking cable release and the *B* setting on your shutter dial), the planet acts like a giant turntable. The result is a carnival-like whirl of celestial lights spinning across the nighttime sky.

You need three things to create this astral illusion successfully: a sturdy tripod, a dark location, and a starry, moonless night. Be particularly careful to choose a location away from city lights or other extraneous lights. Also, although the star trails are intriguing subjects in themselves, the technique works best when there is a recognizable foreground subject—treetops or a chimney, for example. This scene is particularly appropriate because the star trails frame the observatory.

How long an exposure? It will depend partly on the speed of the film you're using and partly on the degree of effect you're after. An exposure of 15 minutes with a medium speed (ISO 100) film will "streak" the stars, while an exposure of several hours will create trails across the entire frame. To create the dazzling circular trails shown here, aim the camera at the North Star.

Soft focus

In this photograph, the photographer added a pleasant touch of lightness and romance to the picture by using a soft-focus lens. You can achieve the soft focus effect with a soft-focus lens, a diffusion filter, or a fog filter. By "melting" away hard edges and lessening the contrast, you can create a quiet, ethereal, or even sentimental mood that's pleasing.

Commercial diffusers are inexpensive and come in a variety of intensities, with effects ranging from a mild softening of the images to an overall mist-like diffusion. You can also make your own diffusers. Just smear a thin layer of petroleum jelly onto an old skylight filter. You can also use a square of window screen; a piece of clear (or colored) cellophane; a clear, plastic bag; and even a clear, plastic filter case held in front of the lens. On a cold day, try breathing on your skylight filter and take the picture as the condensation evaporates.

Regardless of the specific device, the lens aperture also controls the degree of softening: the larger the aperture, the greater the diffusion and vice versa. If your camera has a depth-of-field preview button, you can preview the effect in the viewfinder. With or without a preview button, it's best to keep apertures in the $f/2$ to $f/5.6$ range to avoid defeating the diffusion effect.

Soft-focus attachments work particularly well with high-key (light-toned) subjects and scenes (like this one) that are strongly back- or side-lighted.

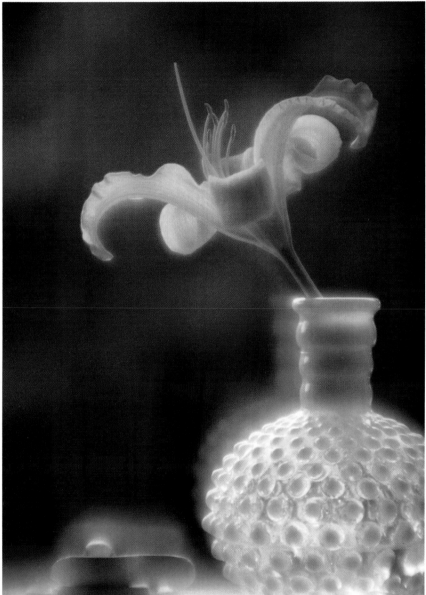

Derek Doeffinger

Photographer's comments: *"I like to photograph objects about the house. I included the window latch for both its compositional value—it counterbalances the vase and repeats the color of the vase—and its psychological value as a common household object."*

Hand Coloring

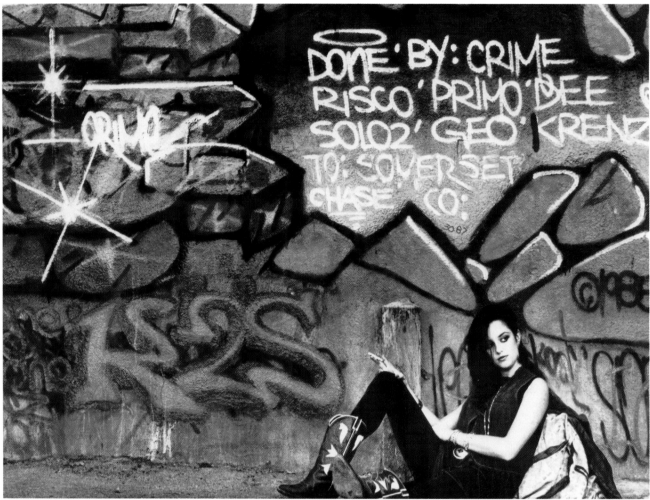

Audra Reinsch

Not all color photographs begin their lives on color film—some are actually transformations of black-and-white originals. One of the most popular methods for adding color to black-and-white prints is a technique called *hand coloring*. The fun part of hand coloring is that you can color as little or as much of a print as you choose—and you can be as realistic or as imaginative as you like.

You can color prints with any number of media, ranging from felt-tip markers to food coloring to professional dyes and oil colors. For coloring certain details of a print, felt-tip pens or food coloring applied with a

fine artist's brush are the simplest (and least messy) approach. KODAK Liquid Retouching Colors work well for coloring small areas, while KODAK Retouching Colors in jars are great for larger areas. For an overall tint, try swabbing the print with (or soaking in) a dilute mixture of food coloring or black coffee.

If you find that you enjoy the concept of coloring and would like to attempt more sophisticated projects—like the quasi-realistic image reproduced here—use a hobby kit such as Marshall's Photo Oil Colors. Using these oils takes some practice, but once mastered they allow you to

create false-color prints that are nearly indistinguishable from actual color prints.

Photographer's comments: *"This photograph was planned; it was taken at an old theater which was vandalized and is now a popular spot to be photographed. By hand-painting the photograph and leaving the woman black and white, I was hoping to make a statement about the isolation of people in society."*

Interiors

Norm Kerr

All of us have photographed a building at one time or another, but most of the architectural photographs we take are of exteriors. Less often do we venture inside the buildings with our cameras. Yet from cathedrals to country chapels, museums to bus stations, building interiors can present some inspiring photographic challenges. And some building interiors, like the Pension Building in Washington, D.C. (shown here), are especially impressive.

One of the reasons photographers avoid interior photography is the inherently low light level found inside most buildings. But low light doesn't necessarily mean no light. In most interiors, it's possible to make a good photograph with a steady tripod or a fast film. A larger problem is lighting contrast. Bright daylight spilling in

from windows often washes out detail, while dark corners remain hidden in shadow. The best solution is to wait for an overcast day when soft, diffuse light will illuminate the interior evenly.

Another problem that you may encounter is distortion—particularly if you're using a wide-angle lens to take in a large interior. Wide-angle lenses tend to distort architectural shapes somewhat. For the shot shown here, the photographer overcame this difficulty by using a view camera which

has corrective camera movements built into its design. Lacking these, sometimes the only solution is to try and work the distortion into a creative effect or find alternate viewpoints. The photographer also chose KODAK T-MAX 400 Professional Film for its high speed and extremely fine grain.

Finally, don't ignore practicing on familiar interiors—your living room, office, etc. Where else are you so in touch with the patterns of lighting and mood?

Photographer's comments: *"Few interior spaces have such an impressive sense of scale as the Pension Building in Washington, DC. Designed shortly after the Civil War as an environmentally stimulating and healthy place in which civil servants could work, this photo was made during recent major renovations. Despite the noticeable presence of some construction materials, the sunshine streaming in evokes a feeling of grandeur."*

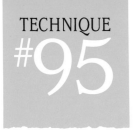
Fireworks

Displays of fireworks can be addictively pretty, and the next best thing to seeing them in person is looking at photographs of them. Of course, not all displays are quite as sensational as this one honoring the 100th anniversary of the Statue of Liberty. Still, any hometown 4th-of-July display will provide many spectacular photo opportunities.

The drama and glamour of fireworks appear most exciting when an entire barrage of colorful bursts are captured on a single frame. To do this, place your camera on a tripod and, with a cable release, lock the shutter open long enough to record several bursts. For this picture taken on KODACOLOR VR 100 Film the exposure was $f/8$ at 5 seconds. To prevent ambient light from overexposing the film, cover the lens between exposures with a lens cap or dark cloth. Once you're satisfied that the frame is well filled with firework bursts, close the shutter and advance to the next frame to try again. Although exposure isn't critical, it's best to use a color negative film because it can often provide good pictures (adjusted in printing) even if exposed improperly. For fireworks, KODACOLOR GOLD 200 Film with your lens set to $f/11$ is a good choice. For an ISO 64 or 100 film, use an aperture of $f/8$. For an ISO 400 film, set the lens at $f/16$. Keep the shutter open up to about ten seconds.

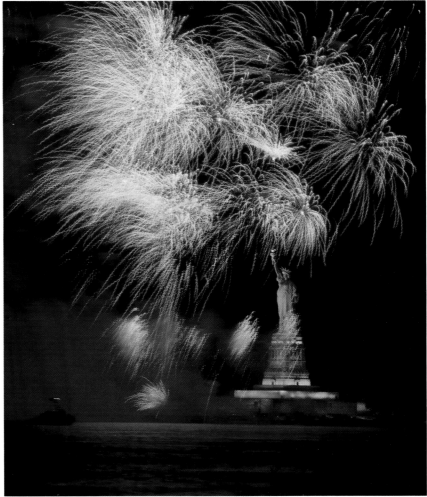

Sam Campanaro

Because it's impossible to predict exactly where the bursts are going to occur, use a wide-angle lens to frame a wider area of sky. To fill the frame with a single burst, use a medium telephoto and try to anticipate where the bursts will occur.

Although fireworks' streaks are colorful and dramatic, by themselves they can simply look like a fiber-optic lamp. To add more interest to your pictures, try to include something in the foreground, such as people, a festival tent, or even a statue.

Photographer's comments: *"This picture was made minutes after President Reagan relighted the Statue of Liberty in celebration of its renovations. This was one of 1900 pictures taken by myself and another Kodak photographer during Liberty Weekend. For this shot I was located on Governor's Island with two tripods and two cameras. I opened the shutter for about 8 or 10 seconds—just long enough for a series of fireworks; any longer and the Statue might have been overexposed."*

Zooming

Derek Doeffinger

Zooming is a motion-simulation technique created by changing the focal-length setting of a zoom lens during a brief time exposure. It results in scintillating streaks of color bursting forth from the center of the frame. The technique works particularly well with bright multi-colored subjects against a dark background—a qualification that this jubilant Christmas display exemplifies.

The magnitude of the streak pattern you obtain will be determined largely by the range of focal lengths of a given lens; the longer the range zoomed through, the bolder the effect. But as the photographer discovered in making this shot, the best photos don't necessarily depend on using the entire available focal range: "The shots made using a full zoom from 35-85 mm looked gaudy and diminished the sense of the house," he recalls. "This small zoom from about 35 to 45 mm accented the bright lights." The photographer used KODACHROME 200 Professional Film and an exposure of $f/5.6$ at two seconds. He zoomed the lens only during the final 1/4 second of exposure.

Synchronizing exposure times and zoom manipulation takes a little practice, but it's generally easier with longer shutter speeds. Use shutter speeds of 1/15 second or slower. Also, use a slow-speed film to allow the longer exposures. For night shots you may be able to use a medium or even a fast-speed film. But for daylight photography, the long exposure times will require slower films. If you are caught without a slow-speed film in your arsenal, you can use a neutral density filter over the lens to reduce the amount of light reaching the film. Since you won't be able to see through the camera viewfinder once you begin the exposure, it's a good idea to use a tripod to ensure that your subject remains framed properly.

Photographer's comments: *"This house was just radiant with Christmas lights, and I wanted to exaggerate that sense of light even more. I tried panning the camera down midway through the exposure to create light streaks and I also tried zooming—which worked best."*

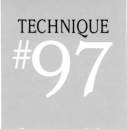
Blurred Motion

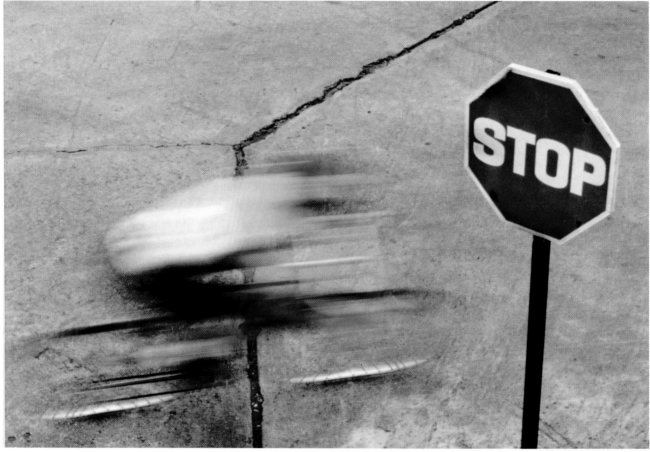

John Kush

With extremely fast shutter speeds of 1/2000 second and faster, most 35 mm SLR cameras pack incredible action-stopping power. But fast shutter speeds not only halt action—they often erase the sensation of speed entirely. Sometimes a better way to relate motion is to let it become part of the image through creative blurring.

Among the things affecting the degree of blur in an action photograph are speed of the subject, direction of travel (relative to the film plane), image size, and shutter speed. You don't have much control over subject speed, but you can use your knowledge of the other factors to create or manipulate the desired degree of blur.

Moving objects—this bicyclist, for example—will produce the most blur when they are close to and moving across the path of the camera. The effect works extremely well for this picture, because it emphasizes that the bicyclist is running a stop sign. The blur will be less when the subject is farther away and heading directly toward or away from the camera. You might stop a moderately fast-moving subject coming toward the camera with a shutter speed of 1/60 second, while the same subject shot from the side at the same shutter speed would appear blurred. So to enhance blur, position yourself parallel to the motion of the subject and use a slower shutter speed such as 1/8 second. Mount the camera on a tripod if you want the unmoving parts to be sharp. To reduce blur, change your position and/or increase shutter speed. If the action is repetitive, try several different shutter speeds to be sure you get a shot that you like.

Motion Filter

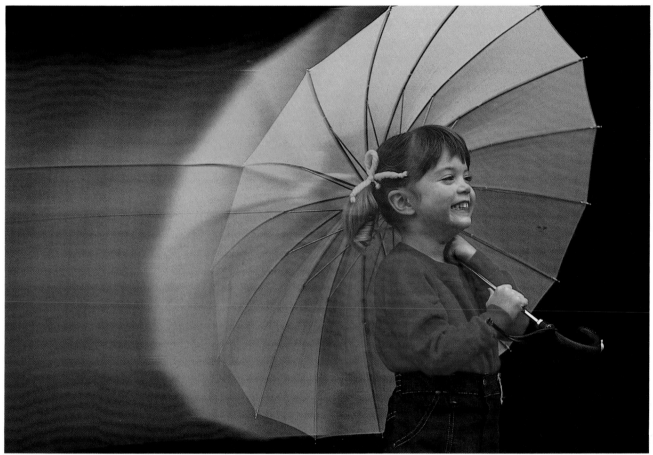

John A. Raub

No matter how seriously we take our photographic hobby, eventually most of us get the urge to grab our cameras and play—to make pictures that are just plain fun. Few gadgets in photography offer as much fun as special-effects lens attachments. Want to shroud a sunny harbor in fog? There's a filter that can create such a mood. Think you'd like to transform an average sunset into a fiery color storm? There's a filter for that, too. Like to see how your cat looks through a kaleidoscope? No problem. With the right filter you can whip up virtually any pictorial potion that your imagination can conjure.

In addition to helping you escape reality for an afternoon, creative filters can produce some interesting images. The stunning portrait above, for example, was made with a "motion" or "speed" filter. This filter refracts light in part of the image to create a very convincing illusion of motion that's similar to a panning effect. Motion filters work best with simple, brightly colored subjects against plain backgrounds.

Whatever attachment you choose, don't think of it as a shortcut to creativity or as a substitute for good ideas. Many photographers have spent a small fortune on lens attachments only to see them gather dust in the gadget bag.

Compression With a Telephoto Lens

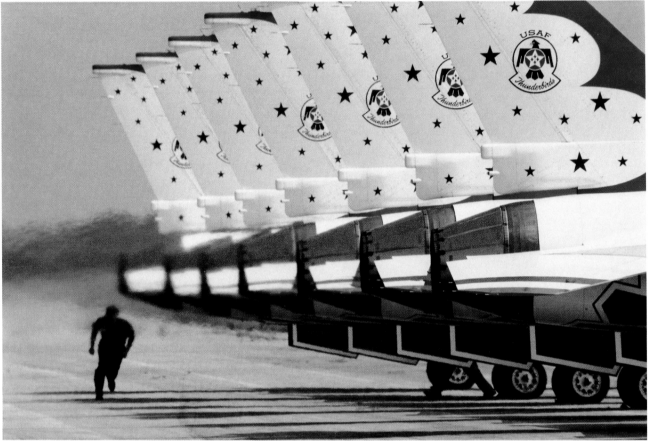

Bob Clemens

Most photographers are familiar with the ability of a telephoto lens to magnify both distant subjects and nearby subjects. Less exploited, though, is the capability of long lenses (especially super-telephotos in the 500 mm range and beyond) to compress the apparent distance between near and far elements or between several distant objects. Like a great optical vise, extreme telephoto lenses squeeze the space out of a scene—leaving behind scenes devoid of depth or perspective.

There are several ways you can turn this space-compacting ability to creative advantage. By making distant objects seem much closer to each other than they really are, for example, you can turn three-dimensional subjects—like the line-up of jets shown here—into highly graphic two-dimensional designs. Or you can use a telephoto's compression power to create false but dramatic size relationships—using a swollen ball of setting sun to engulf a pair of beach strollers. Whatever the illusion, be aware that the increased magnification also reduces dramatically the depth-of-field; you'll have to use a small aperture ($f/16$ or smaller) if you want to keep all the elements in the scene in relatively-sharp focus.

Photographer's comments: *"The precise lineup of the Thunderbird F16 fighters attracted my attention. I chose to emphasize it by using a long telephoto lens (400 mm plus a 1.4x converter, making it a 560 mm lens). I waited until all aircraft had started their engines so as to include the distorted look [caused by hot exhaust] behind their tailpipes. As I began to shoot, a ground crewman appeared… the unexpected addition makes the photograph."*

Traffic Streaks

Steve Goll

The ability of film to record patterns of moving light opens up some very clever and interesting possibilities that you can use for special effects. One of them is the technique of creating taillight streaks, by photographing car traffic at night using a long exposure time. Because the cars are moving, they remain invisible and only their bright lights register on the film. This technique is simple: All you have to do is find a location where there's abundant night traffic and, with the camera on a tripod and the shutter locked open, let the traffic trace its pattern on the film. You can make a very long exposure (several minutes or more) and record the continuous flow of traffic, or leave the shutter open long enough to capture only the brief streaks of a single, colorfully-lighted vehicle as the photographer did here. If you decide to record a lot of traffic, pick a location where the cars will trace an interesting design or pattern—an interstate cloverleaf shot from an overpass, for example.

Also, if you're shooting at traffic level, choose a location that has the taillights dominating the composition, since a long exposure of white headlights coming into the lens may wash out the picture. And remember, you aren't limited to automotive traffic—airplanes, trains, and skiers' torchlight parades make good subjects as well.

Photographer's comments: *"I set my tripod on the sidewalk next to the highway and waited for a bus to pass me. I pressed the shutter release, which was set on B, when the bus was beside me. The light streaks, which came from the tail lights on the bus, ended when I closed the shutter."*

Reflections

Kent Ross

Bessie Rosenfeld

Reflections offer fascinating possibilities for visual design because they often reveal common subjects in unexpected or surprising ways. Sources of reflections are everywhere—in the water of a pond, rain puddles, the shiny chrome of a hubcap, or even the fractured-mirror surfaces of modern architecture—and searching for them can be a fun exercise in visual awareness.

In some cases, you can enhance the power of a reflection by contrasting a subject with its own mirror-image. Like visual double-takes, these scenes enable us to compare both a realistic rendering of a subject and an impressionistic one simultaneously. By showing the goose seemingly staring into its own reflection (above), for example, the photographer has imbued a common wildlife subject with a sense of contemplation and calmness. The shot also proves the point that you needn't travel far in your search for interesting reflected

images—it was taken on the photographer's rural backyard property on an autumn afternoon. The best times to look for glass-like water reflections are early in the day before breezes ripple the surface, or at twilight after they have subsided.

In other situations, the key to capturing a striking reflection is isolating the source of the reflection from its surroundings entirely, so that the viewer has no doubt about your intended subject. Indeed, in the scene of the tuba player (above), very tight cropping was used to focus our attention on the vibrant red and yellow reflections in the horn's glossy metal surface. But as the photographer explains, getting such isolation often takes considerable extra effort: "The musician started

dancing…I followed him—dancing, too, mimicking his movements. When he stood still, I snapped the picture." The inherently sensuous curves and twists of the horn provide an additional level of visual interest. To halt the action and capture a sharp image, the photographer shot the picture using an SLR with a fast (1/500 second) shutter speed.

Whatever the subject or source of the reflection, one thing you must always be cautious of is keeping your own image from appearing in the photograph (unless, of course, *you* are the subject). By exploring your subject from different angles, you can often find a vantage point that captures the creative design you want, without including yourself or other distractions.

Further Reading

The Art of Seeing
(KW-20, CAT. No. E144 2250)
Shows you how to take better photographs by studying the elements of the subject, using lighting, and composition, color, shape, form, texture, and viewpoint. Explains how cameras, lenses, and films see differently from you. Suggests ways to achieve creativity by shattering preconceptions and lack of awareness. Helps you break through creative barriers.

96 pages 8 1/2 x 11"
Over 170 illustrations
ISBN 0-87985-747-1

KODAK Guide to 35 mm Photography
(AC-95, CAT. No. E112 0005)
For the new 35 mm camera owner or for the more advanced photo hobbyist who wants to brush up on the basics. Covers such topics as camera handling, Kodak films, exposure, flash, lenses, and composition. Contains hundreds of colorful examples of good pictures.

272 pages 6 x 9"
Over 400 illustrations
ISBN 0-87985-613-0

KODAK Pocket Guide to 35 mm Photography
(AR-22, CAT. No. E123 0861)
Provides on-the-spot information for almost any 35 mm problem. In addition to explaining camera, flash, and filter operations, the guide discusses photographing action, nature, people, and landscapes. Also contains information on existing light, special effects, and more.

112 pages 3 1/2 x 6 1/4"
Over 200 illustrations
ISBN 0-671-69562-2

How to Photograph Babies & Children
(AC-230, CAT No. E130 1000)
Describes and explores ways to produce photographs that will provide a lasting and rewarding record of a child's life. From baby to young adult, from formal portrait to vacation snapshot, the book contains advice on photographing a variety of situations and occasions with tips on improving your skill and picture presentation. Also included is a section on the specific challenges of photographing babies.

144 pages 5 1/2 x 8 1/8"
Over 150 illustrations
ISBN 0-87985-001-9

Index